How to draw and sell
CARTOONS

All the professional techniques of strip cartoon,
caricature and artwork demonstrated.

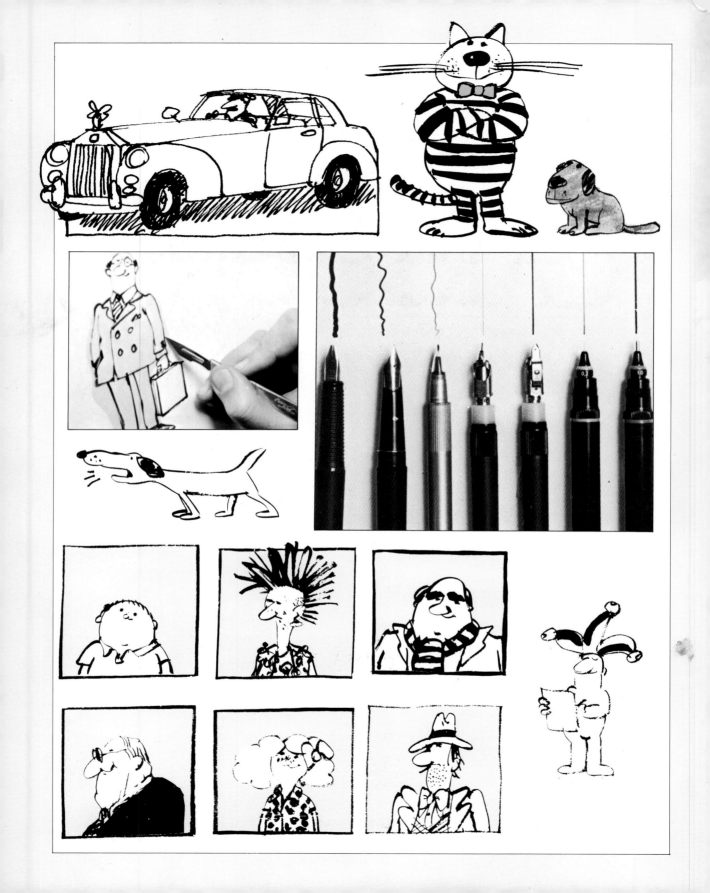

How to draw and sell

CARTOONS

All the professional techniques of strip cartoon,
caricature and artwork demonstrated.

Ross Thomson and Bill Hewison

North Light

CINCINNATI, OHIO

A QUARTO BOOK

Copyright © 1985 Quarto Publishing Ltd

Published in North America by
North Light, an imprint of Writer's Digest Books
9933 Alliance Road
Cincinnati, Ohio 45242

ISBN 0-89134-157-9

This book was designed and produced by
Quarto Publishing Ltd
The Old Brewery, 6 Blundell Street
London N7 9BH

Senior Editor Jane Rollason
Editor Tish Seligman

Art Editor Moira Clinch
Designer Anthony Bussey

Photographer Ian Howes
Picture research Kate Parish

Art Director Alastair Campbell
Editorial Director Jim Miles

Filmset by Text Filmsetters Ltd, Orpington & London
Color origination by Rainbow Graphic Arts Co Ltd, Hong Kong
Printed by LeeFung-Asco Printers Ltd, Hong Kong

Contents

Foreword 6
by Norman Thelwell

Section 1
Techniques and materials 16
by **ross**

Section 2
Evolving a style 50
by **ross**

Section 3
Cartoon styles 104
by *Bill Hewison*

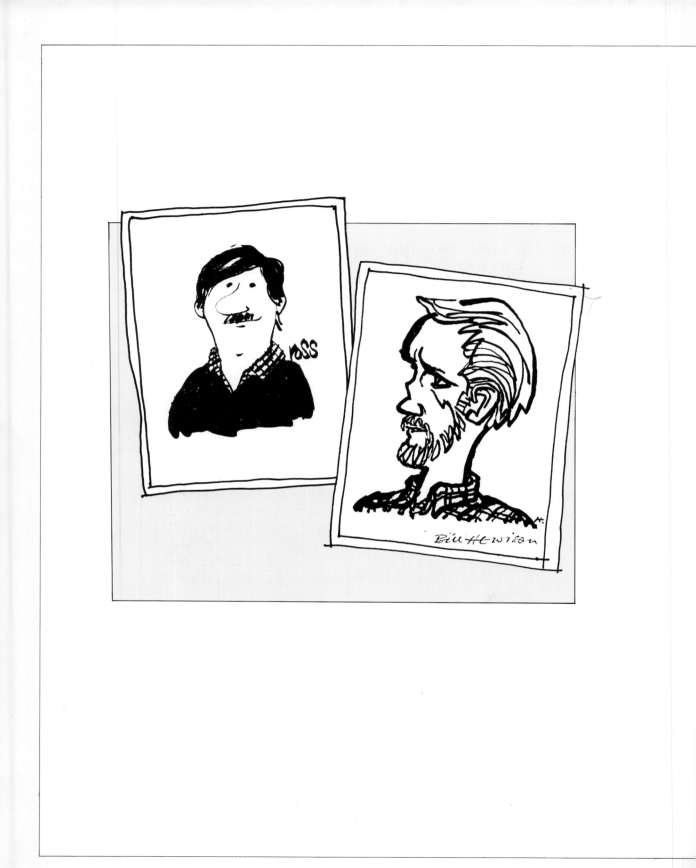

Foreword

Art schools teach many aspects of the visual arts but I know of none which takes humorous art seriously. This may well be the reason why professional cartoonists are constantly bombarded with questions from those who are ambitious to become humorous artists themselves.

The questions, on the whole, follow much the same line. 'Where do you get your ideas from?' 'How do you make a start in the profession?' 'How do you develop a personal style of drawing?' 'How do you set about trying to sell your work?' They are not the kind of questions one can easily answer in a letter and I have often wished that I could refer correspondents to a reliable source of information written by experienced professional artists. Bill Hewison and Ross Thomson have now produced just the right kind of book.

How to Draw and Sell Cartoons is crammed with information on every aspect of the cartoonist's world, written by top rank professionals who know their job. It is an invaluable reference book for the aspiring cartoonist, containing as it does the kind of information and knowledge of the subject which took most of us years to acquire.

Furthermore, it's great fun to read.

Norman Thelwell

The joke cartoon in general

Just about everybody can draw a cartoon of some sort. But there are only a few who can draw a *good* cartoon. The very simplest and crudest of drawings, provided we have no trouble in recognizing what it represents, can strike us as being funny in itself or can deliver to us a funny idea. Nothing is laid down, there are no strict rules – anything is possible.

Or rather, that is what we tend to think. In fact, there are a great many hidden half-rules, little tricks of the trade and practices which have infiltrated the whole activity of cartooning and it is the knowledge of these, plus individual flair, which lifts what could have been an ordinary cartoon into something of quality.

The professional cartoonist is a professional (in that his cartoons are published) because he has learnt to employ certain skills and to avoid certain bad practices. Maybe he achieved his position by regularly scrutinizing a wide field of cartoonists' work; maybe he plodded through a laborious apprenticeship of trial and error. The purpose of the following pages is to offer practical and general guidance to the budding cartoonist and provide him with signposts which will offer short-cuts to his destination – and that 'good' cartoon.

'A cartoon is good only if an editor takes it.' Thus spoke old Laurie Siggs, a veteran cartoonist. It is a neat sentence which sums up with a delicate irony the

We all recognize the fact that certain subjects keep turning up in cartoons time and time again – so often, in fact, that they become cartoon clichés and take on a separate life of their own. Anybody's list would include the psychiatrist's couch, Noah's ark, learner drivers, marauding Vikings, would-be suicides, and sight testing – but the daddy of them all is the desert island. Why this subject should have persisted so long is a mystery beyond explanation, but there is no doubt that cartoonists have contrived countless variations on this theme, and are still at it. This one by Raymonde recognizes the cliché and makes a joke about *that*.

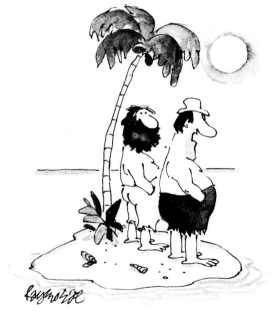

'If you must know – I won a world cruise in this cartoon caption competition.'

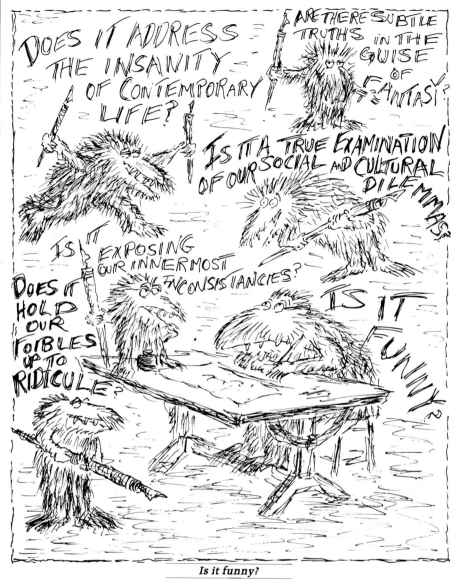

Is it funny?

Another cartoon about the business of cartooning, this time by Koren. Here he assembles his characteristic menagerie of hairy monsters to represent a gaggle of cartoonists worrying away at the principles of their trade. As Koren maintains, the bottom line is always, 'Is it funny?'

very nature of humor as well as the hazards facing the professional. Humor is very subjective; none of us has quite the same response to a funny event because each of us has been conditioned by our own accumulated experience and knowledge to react in our own particular way. Fortunately there are enough people around who respond to comedy in a similar fashion, otherwise clowns, comedians and cartoonists would have a very rough ride. It must be remembered that a sense of humor is not part of the kit we receive at birth. We have to work at it and learn the rules as we go along and be prepared to do some canny footwork when the rules change, because they are changing all the time. Looking back at nineteenth-century cartoons, those naturalistic and detailed illustrations with yards of dialog, we wonder how anyone could think such feeble stuff was funny, but to the Victorians it was. So who can confidently predict that the cartoons which send us into guffaws in the 1980s will not be dismissed as

pathetically unfunny by our descendants in a hundred years' time?

It is an accepted fact that few cartoon ideas come in a blinding flash of inspiration or are casually plucked out of the air. Most are sweated out through sessions of deep concentration – as veteran *Punch* cartoonist, David Langdon, puts it, '. . . through a process of controlled mind wandering'. And James Thurber once wrote, 'The hardest part of my job is to convince my wife that I am working when I am standing staring out of the window.' Usually a subject or theme (picked up from any source) provides the starting point, but nobody knows how the creative process works. It seems that a humorist is someone whose mind operates in a certain way, who has the knack of making those vital connections. And, just like playing a musical instrument, the more cartoonists work at their trade the better they are likely to get.

But, in the structure of practically all cartoons there is a common strand – the element of surprise. We all know that cartoons have a 'point' and it is up to us, as readers, to dig it out. Some are sharp and definite, some are subtle and slippery to grasp – we search around and, once we find it, the discovery triggers off this spasm of surprise, this little explosion of amusement and appreciation. The cartoonist, in forming his cartoon, has therefore to put it within the framework of a little riddle. He sets the scene, provides the clues, holds off the flash-point until the reader has interpreted all the information. This 'delay' effect is best demonstrated in those elaborate drawings where the significant element of the cartoon is partly

A sharp piece of satire from William Scully, a cartoonist who has long kept a beady eye on the foibles of social behavior in all its manifestations. We enjoy his little barbs – except on those occasions when he comes knocking at our own front door. He is not one of the 'bent wire' school of artists. He works like a painter with tone and space, but in a full and lively style.

"Good grief ! The two books they leave lying about are the same as ours."

Leonardo at work

Arnold Roth enjoys the act of drawing and painting – as is quite evident from this example of his work. He believes in giving the customers their money's worth and will not dodge round difficulties by fudging or resorting to a bit of childish art. All his drawings are constructed and composed, but this does not mean they are academically stultified. Roth is a very funny man and his drawings are very funny in themselves. This example is less bizarre than most. Elsewhere his characters are given severe and satirical distortions, to powerful effect.

hidden, or in those cartoons where the vital trigger is saved until it appears in the few final words of the caption.

Where to start

Budding cartoonists should not, however, be too overawed with this kind of analysis; the best way to learn how to become a creator of funny ideas is by example. All cartoons are derivative to a great or small extent. Even those people who pioneer absolutely new areas of the craft have already looked at lots of cartoon humor, have soaked up early comics, spoofs, newspaper and magazine cartoon features. So, the first idea the aspiring cartoonist gets down on paper is usually a variation of something he had already seen published. He is also usually an admirer of one established cartoonist and his drawing style is therefore heavily influenced by that cartoonist's style.

Most of today's successful practitioners started by walking in the footsteps of a major stylist or innovator – master cartoonists like André François, Peter Arno, Ronald Searle, Carl Giles, Saul Steinberg, Fougasse, Walt Disney, a group which promoted a shoal of imitators who then gradually edged their way towards their own personal and distinctive styles. More recently Quentin Blake in Britain has spawned a lot of acolytes, whilst the American caricaturist David Levine finds he now has a school of followers tagging briskly along in his wake.

Beginners can also learn how to compose their pictures and how to achieve their effects from established cartoonists. What they must always keep in the forefront of their minds, however, is the fact that the main purpose of the drawing is to be a vehicle for the idea. No tricksy or elaborate drawing should be allowed to get in the way of that prime purpose. The drawing – no matter how stylish, personal, quirky or grotesque – should always deliver the goods. This does not necessarily mean that everyone should pare everything down to the barest of essentials, though it is true that many cartoons are a form of pictorial shorthand; they should also strive to catch a mood, characterize a particular kind of locale or a certain sort of people. Charles Saxon of *The New Yorker* pins down

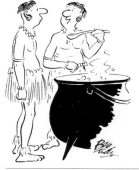

'It contains the health-giving vitamin Jim Smith.'

If desert islands are the most hackneyed of cartoon subjects then cannibal pots come closely behind. This one demonstrates that the key words in a joke are always best placed at the end of the caption – 'Jim Smith' in this case. It is an excellent example of the important delayed effect.

his East Coast sophisticates (pseudo-sophisticates?) with a deadly accuracy; Carl Giles's affectionate depiction of the British blue-collar worker and his family is unsurpassed. In France, Jean-Jacques Sempé turned his eye on the cosy world of the French middle class and his cartoons had warmth and charm, and like Giles, an affectionate regard for his subject. Recently, however, he deliberately changed his style of drawing to one which is looser, tentative, more self-consciously 'artistic' – a development which many of his admirers have regretted. These three cartoonists have probed right under the skin of the people they draw and their jokes come out of a close observation of a particular life-style; they focus on a characteristic situation, then send it up to a form of heightened reality. We recognize the situations and what the cartoonists are doing with them because they are attached to normal everyday life; for these we do not – as for some cartoons – have to be armed with some special knowledge.

Other cartoonists, like the idiosyncratic James Thurber and the down-to-earth Bill Tidy, also keep themselves firmly linked to the real world of human behavior, but they lift their pictorial commentary onto strange, often surreal, flights of inspired fancy. The reality is there, but it is turned on its head or squeezed into a bizarre shape. Thurber's, 'All Right, Have It Your Way – You Heard a Seal Bark!' is the archetypal Thurber cartoon – a much quoted classic which demonstrates, as well as any of his other drawings, the autographic style of a half-blind, untrained artist. That fluid, slightly awkward line is exactly right for his brand of humor. Bill Tidy has had no formal training either; he is completely self-taught and a natural. He seems able to draw anything and anyone from any viewpoint; he has a tremendous visual memory. On the so-called difficulties of perspective he once said: 'Perspective? Perspective is what you *see*, so what's the problem? It's there – if you can't see it you must be daft. And he is right. Both he and Thurber are humorists cast in the zany mold,

Michael Heath is one of the most prolific cartoonists working today. But this does not mean he knocks off wispy and austere drawings. Heath seems compelled to put in all those correct details each drawing requires – he has an astonishing visual memory in this regard. But this 'accuracy' of detail is caricatured so the result is doubly effective. He is alive to every changing nuance of fashion, design, and the appearance of things. Any technological object in a Heath drawing will come from his imagination but, paradoxically, will look more like the object than the object itself.

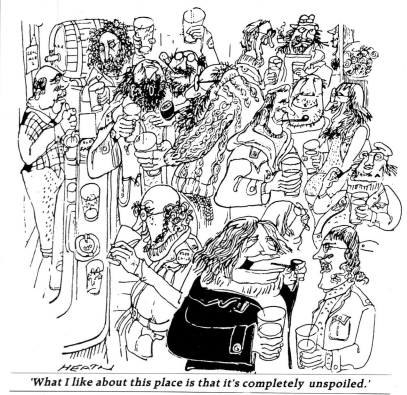

'What I like about this place is that it's completely unspoiled.'

'I'm surprised not to find apathy on the list of notifiable diseases.'

This topical pocket cartoon is deliberately mannered. Barry Fantoni is a trained artist and can produce naturalistic paintings as good as the next man. But his unique kindergarten style is eminently suitable for the small, tight format.

'Carry on, you were saying how you would have handled the British boat in the America's Cup.'

but, if it were possible to set up an exercise where each drew the other's ideas, the results would most probably show failure. A cartoonist's drawing style seems always to 'fit snugly to his style of ideas. They are the two sides of the same coin.

Sunday Cartoonists

Bill Tidy is one of those occupying the highest echelons of the cartoonist's world, but in the beginning, like most cartoonists, he struggled and learned and persisted until he got a foot on that escalator taking him towards an achieved success. He has drawn a daily strip for a national British newspaper and produces a fortnightly strip for a magazine; his 'single' cartoons have appeared in the British magazine *Punch* over many years; he does drawings for advertising and illustrates books and book-jackets. Is it possible, then, to be a mere dabbler, a sort of 'Sunday Cartoonist' just for the fun of it? Yes, it is, but there must be some regularity and continuity – this is the only way in which ideas are improved and competence advanced. There is, however, another important facet to the whole business, one very close to that old teaser: would the painter, Pablo Picasso, for instance, have continued to produce his paintings if he had been isolated on the top of a mountain with no chance of anyone ever seeing his work? Art is, after all, a means of communication. And so is humor, basically. You do not stand in the middle of a field telling a joke to yourself. If Robinson Crusoe had passed some of his time drawing a cartoon or two and felt he had devised one of those great smasheroos, then we are pretty sure he would have shoved it under the nose of Man Friday at the first opportunity. Producing cartoons is a private affair but, once they are completed, there is the urge to show them to others and to see them in print fulfilling their function.

So even dabblers and Sunday Cartoonists should persist in sending their work

If any cartoonist in Britain has a completely universal following it is Carl Giles. His work appeals at all levels of brow and the reason for this is probably because he draws in a fairly naturalistic manner, with his people only slightly caricatured. Above all, there is no venom in what he does. A Giles drawing exudes warm-heartedness, though it makes a point about a topical event. The person speaking the caption to a cartoon is the one with the open mouth. In the drawing above you need to seek her out – she is the world-weary woman in the Land Rover.

The character of the lines and marks produced by a pen nib can vary tremendously but many draftsmen do not take advantage of this facility. One who does is Raymond Lowry. Though this particular drawing has no texture it is full of interesting pen-work. You can see how the strokes have been directed and what pressures he has applied. He also uses a full range of movement lines in the upstairs section. It's a very funny joke too.

'It sounds like those bloody idiots upstairs are playing their Stockhausen records again.'

'Tell me, dear child, which particular horse did you put your skirt on?'

The daily pocket cartoon as exemplified by Osbert Lancaster. His splendid creation was the upper-class world of Maudie Littlehampton, through which he used a regular cast of characters to implement his comment on some passing news item. The cartoon above was published at the height of the mini-skirt fashion.

to the publications which use cartoons (tips on this are given in a later section). There will be rejections and many more rejections but come the day when one is accepted, then on that day the sun will really shine. Every cartoonist can remember vividly every detail of his first printed cartoon: the drawing, the caption, the date of the publication, which corner of the page it appeared on. The target has been hit at last; it is a great feeling of elation, and the payment – well, this time that is just an unimportant bonus.

The professionals

The professionals, of course, keep slogging away regardless. They know that of the work they produce there will always be more rejections than acceptances. That is the nature of the game; it is just the ratio that varies from cartoonist to cartoonist. Unless he is under contract to a newspaper, he has to submit his offerings on a speculative basis no matter how well established and successful he is. But once his cartoons are appearing in print regularly, he will find that other areas of activity present themselves to him. Advertising agencies, who have spotted his work, might approach him to carry out a series of humorous drawings for one of their schemes; publishers might require his talents for a book jacket or a few book illustrations. (And charities will lean on him for a free original to put in one of their fund-raising auctions!) So there can be lucrative spin-offs.

But people tend to ask, how do cartoonists keep going, year after year? Are they

Jean-Jacques Sempé is not the typical French cartoonist yet he remains very French. He is not scatological or gruesome but very mainstream. His drawings possess real charm. They even raise a smile before the reader has properly inspected them. He *likes* the people he draws, and he likes the locale and background to their exploits enough to render each stretch of landscape, each street, each house and room, as a real and unique place. His humor is not of the slick, wise-cracking variety but is founded on an affectionate regard for human nature in all its frailties and foibles. M. Hulot and Sempé share the same world. This drawing shows a little man who epitomizes Sempé's quality of humor.

not worried about drying up, never getting another idea? Well, that concern does hang about in the deeper recesses of cartoonists' minds, but they ignore it because there are ways and means of keeping the pistons moving and the wheels turning. The professionals keep a very beady eye on the progress of the rest of their gang; they scrutinize and scan, they admire and criticize. And they are stimulated by what they see. They notice a cartoon which presents them with a brand new theme, some area which had not occurred to them or they were quite ignorant about. So they set to work to devise a variation, an extrapolation which carries them sufficiently away from that first cartoon and any accusations of plagiarism. This is fair enough. The variations on the original can then multiply and, before very long, a new cartoon cliché is firmly established.

It would be interesting to know who drew the first Noah's Ark cartoon, or any of the other standard clichés such as the psychiatrist's couch, eye-testing, the Trojan horse, mirages, lovers' leaps, marauding Vikings, desert islands, and so on. We do know that the Scotsman Alex Graham (the Fred Basset man) was the originator of that long line of 'Take me to your leader' jokes, only his caption was 'Kindly take us to your President', and his drawing, which first appeared in *The New Yorker*, showed a couple of Martians outside their flying saucer and talking to a horse.

Working out a further variation on any of these cliché themes might be a good exercise to start off the apprentice cartoonist. But keep off desert islands, which have been done to death – unless you have a new slant.

Section 1

Techniques
and
materials

IT IS OFTEN DIFFICULT TO TELL just by looking at a cartoon what materials and techniques the cartoonist has used. You might wonder if a line drawing has been executed with a pencil, pen, felt or fiber tip pen, or brush, using ink or paint. It pays to get to know the materials available, their individual properties and characteristics, and how each of them can be used to produce particular effects. But keep an open mind as far as traditional uses and techniques are concerned.

Basically, the amateur cartoonist is fully equipped with a pencil and some paper. Once a certain facility has been mastered then other materials can be introduced gradually. The medium you choose to work in will affect the style you eventually evolve, so experimentation is important.

But it is not only your own personal style which has to be considered by the cartoonist. Who and what are you drawing cartoons for? You will find different publications vary in the style of cartoon accepted. This is often influenced by the method of printing used and the paper it is printed on. It is all very well concocting a masterpiece of wispy lines and washy tones for an expensively produced gravure magazine, but send the same work to a newspaper which uses poor quality printing methods and paper and your cartoon will be rejected. Not because it is a bad cartoon, but because, if accepted and printed, it would disintegrate into a black morass.

Your style – and therefore technique – has to be matched to the job, so a cartoonist needs to be technically flexible and resourceful. Most cartoonists, once established, find they have a favorite medium, but flexibility will increase your chances of survival.

Pen and ink

Pen and ink has been used as a drawing medium since classical antiquity. But the contemporary range of pens and fittings would have astounded those early reed pushers. The versatility of the pen can be used to full effect by the cartoonist as it is particularly suited for reproduction by most printing methods. It can embrace a wide range of drawing styles and techniques too – flowing lines which fluctuate as pressure or angle is modified, short jabbing strokes, or snowstorms of ink dots. The complexities of plastic form and tone can be expressed through hatching – series of parallel lines – or stippling. Pen and ink is often used in conjunction with other media, especially with an ink or watercolor wash to produce a softer style. The cartoonist may eventually settle on a particular pen; but to reach this position he will need to experiment with the different pens and nibs available and discover their infinite possibilities.

Types of pen
The pen you choose is often a matter of preference although certain pens are recommended for special effects.

Dip pen In every cartoonist's tool-box, there lurks a dip pen and a bottle of Indian ink. It may not be in constant use but it will be constantly used.

A dip pen consists of a penholder which is fitted with a steel nib (known confusingly in the trade as the 'pen'). Penholders come in a variety of sizes. Some nibs require special holders, such as the mapping pen, but otherwise the best holder is the one which suits you. It is a matter of trying them out. Then have fun experimenting with the nibs. One of the advantages of the dip pen is the variety of nibs available – thick, thin, square, chisel-shaped, flexible and rigid. It is these traits – width, shape and flexibility – which govern the character of the line. Start off with a mapping pen, and then increase your collection. You will find the rigid nibs will last longer than the finer, more flexible nibs.

The nibs can be easily changed though the process is a trifle messy. Veteran dip pen users splash out on a holder for each of the nibs they use most – the low cost of holders being another of its attractions. Also an advantage is that the dip pen can be used with both waterproof and non-waterproof ink. But whatever you use, you should wash the nib after use in warm water or cleaning fluid.

Charging your pen Most people maintain that having to dip the pen in ink is a disadvantage and this obviously makes it difficult to use on the move. Some, however, consider this method technically an advantage. Dipping the pen means you can control the amount of ink you draw with – dipping often for thick fluid lines, or scantily for light delicate work. This takes practice, but first of all learn to judge the duration of the ink supply so as to avoid running out mid-line.

In color work the pen can be charged with a pipette (or eye-dropper) to avoid mixing the inks. Many of the inks are sold with pipette tops.

Paper The paper you use will affect your technique so you should experiment with different types (see pages 48-9 for paper types). If the paper is too thin or too soft textured it will become easily saturated with ink so that the surface will be ruined and paper will clog the nib. As a general rule, the finer the nib you use the smoother the surface of the paper will have to be.

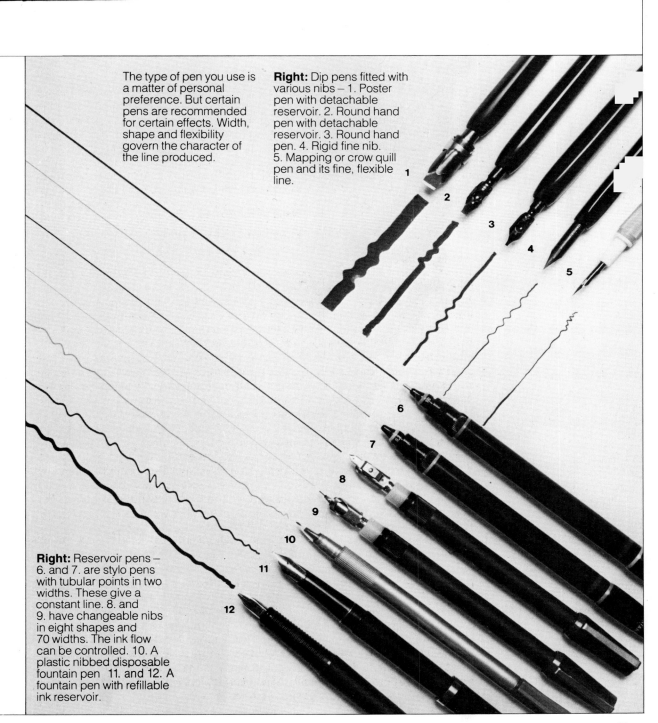

The type of pen you use is a matter of personal preference. But certain pens are recommended for certain effects. Width, shape and flexibility govern the character of the line produced.

Right: Dip pens fitted with various nibs – 1. Poster pen with detachable reservoir. 2. Round hand pen with detachable reservoir. 3. Round hand pen. 4. Rigid fine nib. 5. Mapping or crow quill pen and its fine, flexible line.

Right: Reservoir pens – 6. and 7. are stylo pens with tubular points in two widths. These give a constant line. 8. and 9. have changeable nibs in eight shapes and 70 widths. The ink flow can be controlled. 10. A plastic nibbed disposable fountain pen 11. and 12. A fountain pen with refillable ink reservoir.

A wide range of effects can be achieved with ink. It is important to experiment in order to find which effect suits which purpose.

For tonal expression, roughly hewn hatching with pen and ink makes a striking effect.

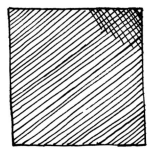

The cross-hatching in the corner is used to intensify the tonal value.

Fountain pens These pens have a reservoir which is filled through suction. Their great advantage is that they are easily transported and used, but there are not so many nib variations, and most brands will not take waterproof ink.

Reservoir pens Designed for graphic designers, these pens have many advantages for the cartoonist. The reservoir, which supplies the pen with ink, is filled by hand using a specially-shaped ink container. The pens are said to work better with their special inks which are slightly thinner than drawing inks and are waterproof.

Most reservoir pens are fitted with stylo tips of interchangeable widths. The stylo is a tube which acts as an ink channel and produces a constant line. This line does not alter very much even when pressure is applied or when the angle of execution is altered – rather like a ball-point pen. There is a reservoir pen, on the other hand, which has a useful range of easily interchangeable nibs, rivaling the dip pen. One model has eight shapes and 70 nib widths.

To keep reservoir pens running smoothly, always replace the cap when not in use and regularly dismantle and immerse the pen in warm water or cleaning fluid. To store them, the reservoir should be emptied of ink and the pen thoroughly cleaned and dried.

Inks

The cartoonist, if producing work for print, must present work which will reproduce well. The type of ink used is therefore important. To a certain extent, the pen you use will dictate your choice as will the support you are drawing on; there are special inks for special surfaces, such as acetate or film.

Drawing inks Made especially for artists, these waterproof inks come in a wide

A textured area is achieved by running back and forth until it's almost filled in.

Here the pen has been drawn across an area of wet paper so that the line bleeds.

This confluence of hatched and cross-hatched lines produces a small essay in tonal values.

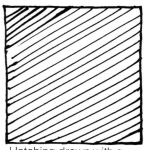

Hatching drawn with a ruler is stiff. Freehand produces a more relaxed effect.

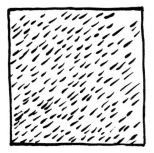

Jabbing lines are used to illustrate texture or as background tone.

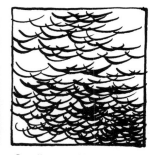

A crazed line can fill an area and give the impression of depth.

Small curved lines can be used to soften the effect of cross-hatching.

Stippling can express shadow, tone or texture. For consistency use a stylo.

range of colors. They contain dissolved resin which dries quickly to a glossy finish, making it possible to overlay with another color. This finish is particularly suitable for reproduction and, of course, being waterproof, will not smudge or run. Drawing ink, you will find, tends to give a more incisive line which does not bleed into the paper. It is also particularly useful when used with an ink or watercolor wash as, once dry, it does not run.

Indian ink is just black drawing ink although different brands vary slightly in density. Any drawing ink can be diluted with water – preferably distilled water – for effect or to counter evaporation if necessary. Indian ink is still considered the only durable, light-proof ink. Most cartoonists, however, only think of the short-term durability of their work – for instance, will the cartoon be ruined when the editor thumbs through his vast pile of submissions? But, in fact, published cartoons are often bought and framed so it is worth using ink that will not fade.

Non-waterproof inks There are various types, such as the narrow range of writing inks commonly used with fountain pens, which are thinner and therefore not recommended for reproduction work. Also available are special drawing inks which are available in various colors and behave more like watercolors. They tend to be absorbed more easily by the paper and dry to a mat finish. Overlaid washes will combine as the ink is not waterproof. The pigment in non-waterproof inks tends to settle, so shake the bottle before use and add distilled water if evaporation has occurred. Before you submit a cartoon drawn with non-waterproof ink, it is wise to spray the piece with fixative which will protect your work from smudging and the other hazards of editorial offices. You can buy it from any art supplier.

Brush and ink

For cartoon work, a brush is probably as often used as a pen. For many, the true advantage of a brush over a pen is its flexibility and lightness of touch – a 'brush man' regards pen and ink as an unforgiving medium. Many of the techniques possible with a pen can also be executed with a brush – producing a fine fluctuating line, hatching or stippling, for example. But a brush can also achieve areas of delicate tonal modulation and flat areas of color or tone. Many cartoonists use both pen and brush in the same cartoon so the advantages of both can be exploited.

By experimenting with both pen and brush you will find what suits you and your style best. For a more fluid, faster style, you might find a brush more suitable.

Brushes
What brushes should you start off with? The choice can be bewildering. Brushes come in different sizes, shapes and materials. Do not be tempted by the cheaper brushes for, as a rule, price reflects quality. The more expensive brushes, if well cared for, last longer and so, in the long-run, are more economical.

Bristle Cheaper brushes are made of synthetic bristle, squirrel, ox-hair or camel and they have their uses for certain techniques, for mixing or priming, but they will not reveal the true potential of the brush. The sable brush is universally regarded as superior. It has a greater capacity for holding paint, it holds its shape for longer and will retain its point when wet. When buying a paintbrush, this last quality should be tested and a container of water is often provided for this purpose (licking the brush will also prove its worth). The brush should not be squashed in any way and should have no stray hairs spoiling an even shape.

Shape and size Brushes are usually pointed (known as 'round') or square-edged, although there are a number of specially-shaped brushes on offer for certain effects. Round brushes range in size from 000 to 14.

To start with, try out a 0 point for line work and a size 8 for broader areas and washes. A square-edged brush of a medium size can be used for such technique as dry-brush and splattering, described below. As a cartoonist usually draws on a table or drawing board, short-handled brushes will be more comfortable. Special effect brushes can be bought later when the need arises.

Care of brush The rarity of the Siberian mink, whose tail provides hairs for the sable brush, contributes to the cost of such brushes and therefore makes the care of your brush of paramount importance. The hairs of the brush are kept in place by a metal ferrule. It is essential that ink should not dry on your brush and clog up the hair close to that ferrule. Dried pigment at the top of the brush will cause the hairs to splay and the brush will lose its shape.

Get into the habit of rinsing your brush – even when you are only pausing to think – in a water pot or under the tap. Never, however, leave a brush downward in a water pot. Try not to 'scrub' with your brush, particularly when mixing, as this can cause damage.

After use, carefully wash your brush in warm water, gently splaying it to let the water penetrate up to the ferrule. Shake off as much water as possible and then dry – again gently – with absorbent paper. Store brushes up-ended in a pot

Top: Always store brushes pointing
Above: Licking the end of a brush will indicate whether it is likely to retain its point.

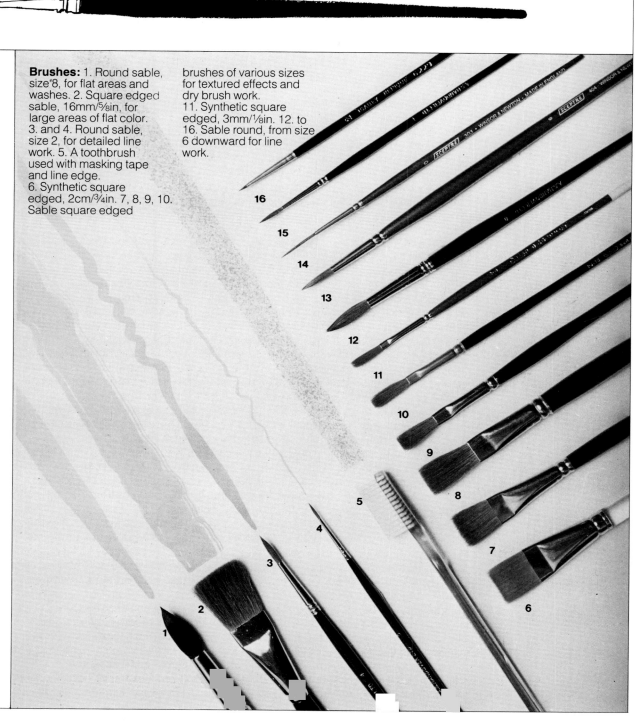

Brushes: 1. Round sable, size 8, for flat areas and washes. 2. Square edged sable, 16mm/⅝in, for large areas of flat color. 3. and 4. Round sable, size 2, for detailed line work. 5. A toothbrush used with masking tape and line edge. 6. Synthetic square edged, 2cm/¾in. 7, 8, 9, 10. Sable square edged brushes of various sizes for textured effects and dry brush work. 11. Synthetic square edged, 3mm/⅛in. 12. to 16. Sable round, from size 6 downward for line work.

(or used coffee jar), although do not allow the brushes to touch one another or their shape will be damaged. For longer periods, store in a moth-proof box.

Inks

The selection of inks available for use with a brush are detailed in the previous section on pen and ink. Mat, non-waterproof inks are very similar in property and character to watercolors so, for the purposes of this section, the character and properties of waterproof inks will be discussed.

Palettes

Ceramic palettes can be purchased, but it is just as effective to use either a ceramic dinner plate or even the border of the paper to mix inks on. The latter method makes it possible to see the exact color that you are mixing for that particular paper.

Water and waterpots

It is best to use distilled water as water impurities can affect certain colors, but it is not essential. Choose a solid, squat water jar, which will not be easily knocked over. A glass one will allow you to monitor the state of the water easily. Try and keep the jar in the same place, so that you do not need to drop concentration when dipping your brush.

Technique

Achieving the wide range of effects possible with a brush and ink takes practice and concentration. Like a pen, a brush needs to be constantly charged with ink. A wet brush attracts dust particles and impurities, so, even if you are not mixing inks, it is unwise to dip the brush straight into the ink pot. Use a pipette (eye dropper) to extract the ink, or, more practically, buy inks with pipette tops. The ink can then be transferred to the palette for mixing your colors or direct to the brush if you are using the ink pure.

Line drawing Much of the cartoonist's work will be line drawings executed in black and white. Buy a pot of Indian Ink and practice with a narrow pointed brush. First of all test out your brush. See what it can do. Charge it with ink and then see what is the thickest line you can achieve and the finest, keeping them straight and even in width. Then try fluctuating lines, getting used to the idiosyncrasies of the brush and ink. Keep checking that you are relaxed, particularly in the arm and shoulder or you will find it difficult to get the brush to flow.

Tonal cartoons Areas of tone in a cartoon can be painted in using varying dilutions of ink with water. As the ink tends to dry quite quickly, it is difficult to cover a large area with a wash without leaving brushmarks. A small area can be covered with a flat wash, however, and, after drying, layers of wash can be placed on top of each other without the colors mixing. Tips given about laying a wash in the section on watercolor will be useful, although do not expect exactly the same results.

The modeling of a figure or shadows can be added in using diluted ink after the initial line drawing has had time to dry. But a different effect can be produced by first drawing your outline with brush and ink and leaving it to dry for a few seconds. Then, with a clean brush charged with water, use the ink supply of the line to produce a wash by touching the brush down on the line and molding it round the form. Alternatively, try building up the tonal areas first and then add the ink outline. You will find the effect will be crisper, and the line will not bleed into the surrounding paint, if the ink of the tonal areas is allowed to dry first. White body color (see the section on gouache) can then be added on the darker areas to form highlights.

Below: Different techniques can be effectively combined in one cartoon to suggest, for example, character — a dense, strong line is used for the fat man's clothing, and faint hatching for the thin man's.

You need not restrict yourself to a brush. This textured pattern was made by thumb.

Here the line fluctuates by varying the pressure with a very relaxed hand.

Uneven hatching made by recharging the brush or varying the pressure applied.

This wooly effect is made by continuous circular motion with the point of a brush.

Variation between these dots is produced by varying pressure on a vertical brush.

This delicate cross-hatching was painted freehand, using a very fine brush.

The ink here was stippled on to a wet surface so that the ink spread.

To achieve a less stark effect, use less ink on the brush for your hatching.

These small strokes vary in strength according to the ink supply.

A crazed pattern with lines running every which way produces an interesting texture.

Splattering is done with a square edged brush. Run your thumb through the hairs.

A large round brush charged with plenty of ink produces a starker, denser line.

25

Fiber and felt tip pens

The felt and fiber tip pen has become an essential part of the cartoonist's drawing armory. As they are available in a wide range of sizes and shapes and charged with different inks of glorious hues, they can be used for a variety of cartoon jobs.

The flatness and denseness of the color when applied is particularly suitable for reproduction and the alcohol-based pens are welcomed for their quick drying property. But many would say that the attraction of the felt and fiber tip pens is their immediacy – they are quick and easy to use; it is difficult to smudge them or cause a blot of ink. Some would say that for this you sacrifice the sensitivity of your art. But there is no doubt that the new generation of felt and fiber tip pen is permitting the artist a sensitivity not possible before.

Pens
The basic dilemma is which pens to buy. You will find that many of the felt and fiber tip pens have been conceived with the graphic artist in mind.

Fiber tip To begin with you will need a fine fiber tip pen with alcohol-based permanent black ink. This is best used for line work but make sure it carries the word 'permanent' otherwise the ink will not be waterproof. This new generation of pen is a marvel to pen-pushers of the past. It appears to be able to achieve all that was held out for the pen – a pure, incisive, yet flexible line. Needless to say there are many who wield a pen who would not agree.

In addition, you will need a range of fiber tip color pens for color work. These can be obtained more cheaply in a set, replacing singly those you use more often as they wear out. Thicker, bullet-tipped markers can be used for color work but tend to leave a mark when used for filling in large areas of color.

Felt tip For blocking in areas of color, you will need a range of larger felt tip markers. The felt is usually cut in a chisel shape which is practical for flat areas of color and can be manipulated to produce a thick or thin line.

If you leave the top off your pen alcohol-based ink can be revived with a few drops of lighter fuel.

Inks
Pens can be obtained containing water- or alcohol-based inks. The former can be used like watercolor on a wash of water but it is not easy to mix them. Alcohol-based inks dry quickly but they are not all waterproof.

Pen care
The life of a felt or fiber tip pen is usually short and many regard this as their major drawback – no sooner have you worked in a pen than the felt or fiber loses its form or the ink dries up. There is little that can be done to prolong the life of the tip but care in keeping the top on the pen will preserve the ink. If your pen does dry up, you can try reviving an alcohol-based ink with alcohol-based lighter fuel. The flow of a water-based pen might flow again with the addition of extra water.

Technique
A fiber tip pen is ideal for trying out ideas, later to be worked up in pen or brush. The pen can be used on almost any type of paper. A layout pad is most useful for

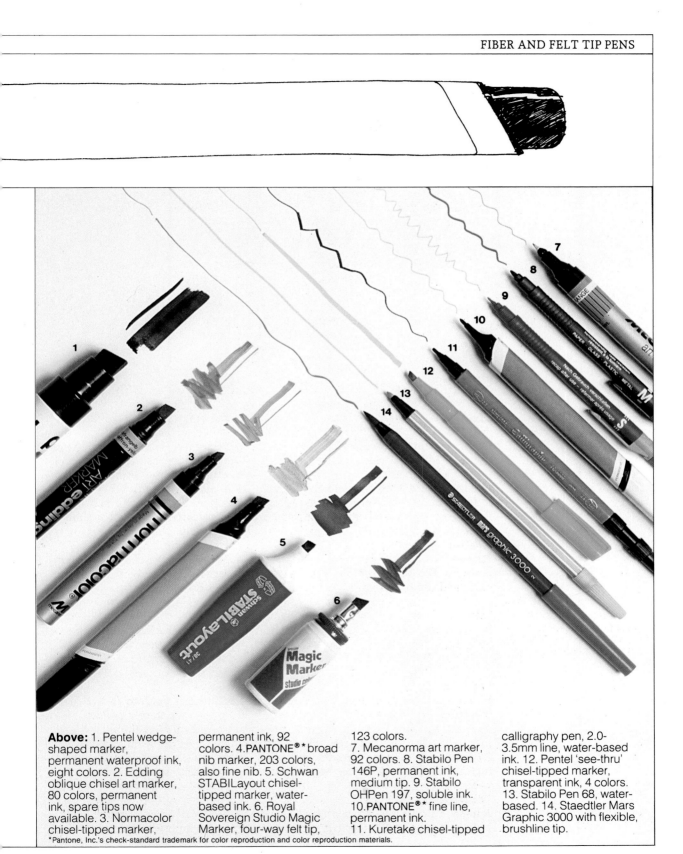

Above: 1. Pentel wedge-shaped marker, permanent waterproof ink, eight colors. 2. Edding oblique chisel art marker, 80 colors, permanent ink, spare tips now available. 3. Normacolor chisel-tipped marker, permanent ink, 92 colors. 4.PANTONE® * broad nib marker, 203 colors, also fine nib. 5. Schwan STABILayout chisel-tipped marker, water-based ink. 6. Royal Sovereign Studio Magic Marker, four-way felt tip, 123 colors. 7. Mecanorma art marker, 92 colors. 8. Stabilo Pen 146P, permanent ink, medium tip. 9. Stabilo OHPen 197, soluble ink. 10.PANTONE® * fine line, permanent ink. 11. Kuretake chisel-tipped calligraphy pen, 2.0-3.5mm line, water-based ink. 12. Pentel 'see-thru' chisel-tipped marker, transparent ink, 4 colors. 13. Stabilo Pen 68, water-based. 14. Staedtler Mars Graphic 3000 with flexible, brushline tip.

*Pantone, Inc.'s check-standard trademark for color reproduction and color reproduction materials.

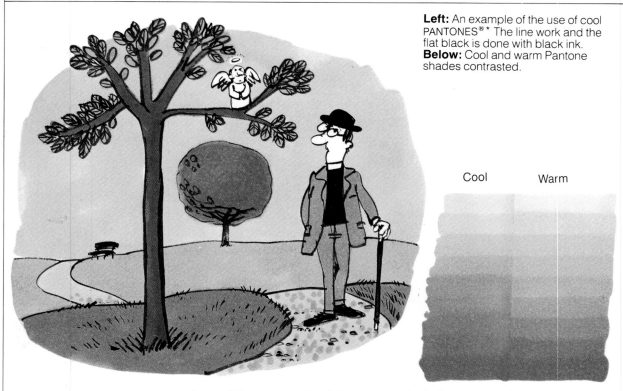

Left: An example of the use of cool PANTONES®* The line work and the flat black is done with black ink.
Below: Cool and warm Pantone shades contrasted.

Cool Warm

rough work but it is made of thin paper which does not work well with some media – too much ink or paint and the paper disintegrates or buckles.

A fiber tip pen seems to inspire rapid drawing. Perhaps the quick drying qualities have something to do with this. For certain types of work it is an obvious choice – a pile of drawings for audio-visual presentation, for example. It is quite acceptable, too, to present rough artwork to an art editor in felt or fiber tip pen when you intend the finished work to be in watercolor or gouache.

Line-drawing The fine fiber tip pen with permanent ink described above can be used to produce a very characterful line. The width of the line can be varied through pressure, with the pen held vertically. The pen can also be held at an angle like a pencil. Used like this, you will find you will wear a flat surface on the fiber tip which can be used to vary the line.

Wearing in such pens, as mentioned above, can be tedious but it becomes a quick job with practice.

Variations in tone can be achieved with linear methods discussed in the section on pen and ink – hatching and stippling – or by using graded greys (see above).

Color work Felt and fiber tip pens come in an exciting range of colors. They are reckoned to be premixed and therefore to be used straight from the pen. Overlaying color is a problem with non-waterproof color as the felt or fiber becomes tainted with the undercolor.

These colors are best used to cover a flat area, producing a style with little tonal variation which is useful for less sophisticated methods of printing. Flat areas of color are best applied with felt tips of a chisel shape. You will find that the ink flow is best with a new pen, so reserve it for larger areas where you want the ink flat. An older marker will leave a striated surface – an effect which can sometimes be useful. Some markers now come with replaceable tips.

*Pantone, Inc.'s check-standard trademark for color reproduction and color reproduction materials.

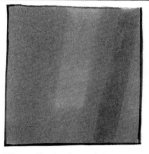

The effect of applying a second coat of PANTONE®* after the first has dried.

Dry effect — leaving the top off a marker can produce interesting results.

This effect is produced by diagonal slashes but leaving white space between them.

The second color has been added after the first has dried – giving a hard edge.

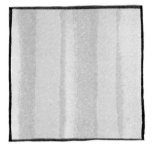

You get green where the blue and yellow overlap, and pure color against white.

Create a subtle wash with grades of grey.

A first coat of color has been soaked with lighter fuel and gone over again to give a flatter tone.

Lighter fuel has been applied to the example, top left, to give a watery effect.

The contrasting applications of felt and fiber tip pens. The felt is used for large areas of color like the lion. But fiber tip pens are too clumsy for detailed work, like the lion tamer's jacket. This was done with a fiber tip pen, as was the stippling on the sawdust in the ring and the line work.

The pencil

We are all familiar with a pencil of one sort or another. But what is its particular use for the cartoonist? Although it can be used for a finished cartoon, it is primarily your workhorse. A pencil is easy to carry around to record notes; it lends itself to sketching and rough work as it does not need special paper and it can be easily erased. A penciled-in idea can be inked over and when the ink is dry, the pencil can be removed.

For the finished cartoon, a pencil produces a sketchy grey line but tonal areas can be achieved with ease. The line becomes denser with reduction. The result is not recommended for newspaper work – although the wax pencil is black enough – but cartoonists submit cartoons in pencil to the better printed magazines.

'Lead' pencils
'Lead' pencils are made of graphite which is graded in degrees of hardness. The most common scale is from 8H (very hard) to H, F, HB, B to 8B (very soft). The hard H pencils do not produce a very dense line but they are handy for tracing round the outline of a drawing which needs to be transferred to another sheet of paper, so that an impression comes through to the paper placed beneath.

For decent reproduction, the B grade pencils are blackest and best. The softer they are, however, the more they have a tendency to smear, so once you have reached your solution with one part of the cartoon, you can spray it with fixative. Once fixed, however, you can not erase it. The other problem with the softer pencils is maintaining a point. Most pencil artists use a craft knife to sharpen their pencils, constantly touching up the end to maintain the sharpness (some use emery paper for this). The electric sharpener is something of a luxury, but very effective.

Standard clutch pencils
A sophisticated form of propelling pencil, clutch pencils carry a range of leads similar in degrees of hardness to the wooden pencil. A special sharpener can be obtained for them. There is one model, designed for architects, which draws a fine line of constant thickness. It is not a soft pencil and the line is on the light side, but they do not need sharpening and so are particularly useful for jotting down the odd idea, particularly when you are on the move.

Audiovisual or wax pencil
These pencils, which have a wax 'lead', are ideal for working on film cel and so are mainly used by character designers working on animated films. The wax – or greasy – pencil produces a good rough line which can be used in general cartoon work and can be used to produce an interesting textured surface.

Charcoal and carbon pencils
Like graphite pencils, carbon and charcoal pencils come in hard and soft grades. Whatever the grade, however, the line produced is densely black. It is always sketchy, though, which can sometimes suit your style. Like graphite, charcoal and carbon work needs fixing.

Above: You will need to get an electric pencil sharpener if you use a greasy pencil.

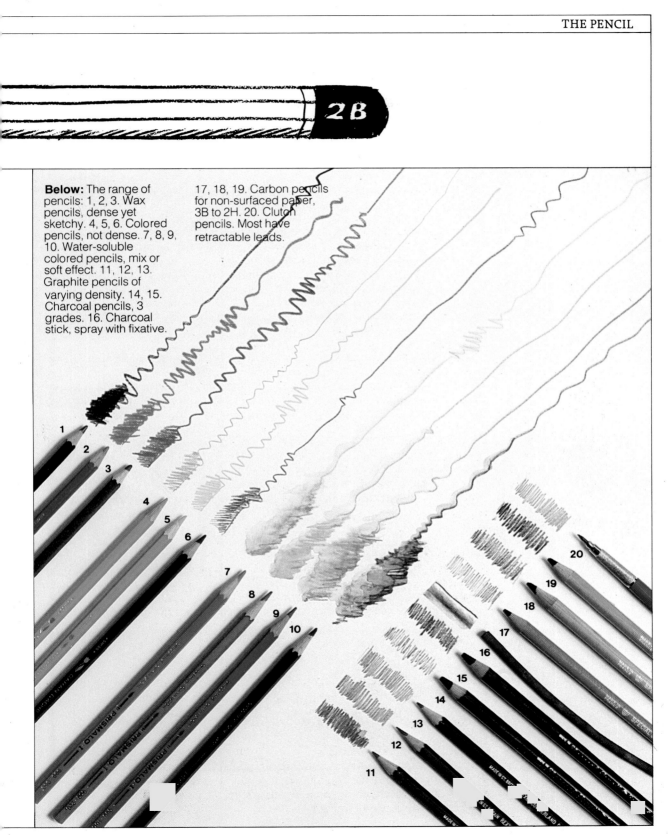

Below: The range of pencils: 1, 2, 3. Wax pencils, dense yet sketchy. 4, 5, 6. Colored pencils, not dense. 7, 8, 9, 10. Water-soluble colored pencils, mix or soft effect. 11, 12, 13. Graphite pencils of varying density. 14, 15. Charcoal pencils, 3 grades. 16. Charcoal stick, spray with fixative. 17, 18, 19. Carbon pencils for non-surfaced paper, 3B to 2H. 20. Clutch pencils. Most have retractable leads.

Colored pencils

Most pencil manufacturers produce very comprehensive color ranges, which can be used to give extra dimension to your color artwork. Colored pencil illustration is undergoing a revival at present. Interesting effects can be made with water-soluble pencils.

Techniques

Whatever pencil you are using, make sure it is sharp. The harder it is, the more pressure you will require. Hard pencils also need tighter control, so softer pencils are easier to sketch with. As pencil smudges so easily, try and work from the top down to the bottom of your drawing and keep a piece of clean paper underneath your hand to stop it smearing your work.

Line drawing A pencil line will not be as incisive as a pen line, so it should be used for its sketchy, grey character. The line, when reduced as most cartoon work is, will appear more dense. The width and sketchiness can be varied by altering the position of the pencil; vertically held, the line is crisper than when the pencil is held on its side. Rub the pencil on some rough paper, holding it as near to the horizontal as possible, and you will create an 'edge' which can be used to fluctuate the line.

Tone The different grades and types of pencil available can produce a wide range of tone. A more linear form of modeling can be detailed by hatching – clearly separated parallel lines – with a pencil from mid-range, or areas of light and dark can be created by rapidly running a softer pencil back and forth, adding more pressure for deeper tone.

Pencil marks can be smoothed over and merged together by gently rubbing with your fingers or thumb. Highlights can be added to dark areas by erasing down to the paper with a regular or putty eraser.

The color from water-soluble pencils bleeds into the surrounding areas.

The mixing of two shades of green by hatching gives the effect of grass.

Graded tone from dark to light, but this time it is done with a purple pencil.

Freehand cross-hatching is used to put pattern on clothing and give tone.

Random-hatching is used for hair, dense matting and to suggest darkness.

Lighter, more controlled hatching is used for color or shadow.

Lighter hatching still, with a finer line, looks almost like dry brush.

Graded tone from black to light grey is used for modeling.

Above: The black outline on the acetate animation cel is out of register with the magic marker-colored underlay to show the separate components.
Right: Positioning the cel on the peg bar in register with the underlay gives the finished effect.

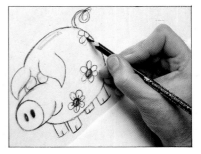

First, make a rough sketch of the general outline of the pig on a layout pad.

Place an acetate cel on the peg bar and position the sketch of the pig underneath it.

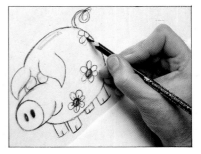

Using an audio-visual pencil trade the picture of the pig on to the acetate cel.

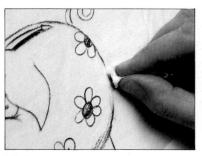

Mistakes can be erased by scrubbing the surface of the cel with a piece of wet tissue.

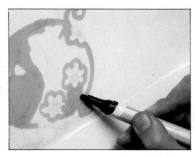

Place layout paper on the cel. The outline of the pig should show through. Add first color.

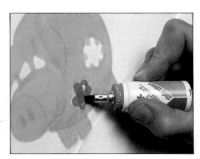

Add second and third color, as required, with a magic marker on the layout paper.

Paint

Monastral blue Ultramarine

Hooker's green Viridian

Cadmium yellow Yellow ocher

Burnt umber Cadmium red

Vermilion Alizarin crimson

Payne's grey Ivory black

There are 24 recommended colors, but a practical palette can be created with only 10 or 11 of these. It is possible to mix colors from primary blue, red and yellow. But mixing takes time and the colors shown above will give you a useful palette.

Watercolor, gouache and acrylic are treated together under one heading because, although they are all used in cartoon work, it is generally in conjunction with other techniques and materials discussed in this section. You might fill in the tonal areas of a cartoon with a watercolor wash, accentuate the linear qualities with penwork and then fill in areas of detail and highlights with gouache or acrylic.

But when your cartoon is printed, it is often difficult to distinguish between the different techniques used. For example, the essential translucence associated with watercolor is usually lost; tonal areas of ink, watercolor and acrylic will look much the same. However, do not forget the original cartoon which survives the printing process and the satisfaction a cartoonist gains from his work.

So, although your preference and your personal style can dictate the medium chosen, the essential qualities and properties of each of these painting methods discussed will prompt their use for certain effects. Experimentation with these diverse paints will allow you to judge which will be useful in your cartoon work.

Watercolor

Watercolor paint is made from finely ground pigment suspended in gum arabic, from the acacia tree. Dried gum arabic can be activated by water so watercolors can be acquired in dried pans or cakes or 'moist' in tubes or bottles.

The main property of watercolor is its transparency. It is possible to achieve an infinite number of gradations of tone between the lightest (the white of the paper) and the darkest (undiluted black), through building up washes – one of the most important watercolor techniques. The transparency of watercolor means that light cannot be laid over dark; a clear idea of the tonal composition of your painting is necessary, therefore, before you start. If, that is, you wish to restrict yourself purely to watercolor.

General comments about watercolors are to be expected, but closer acquaintance with the individual colors will reveal many unique characteristics – some are slightly heavier to handle, some more potent in color and some have better staining power than others.

Watercolor equipment

Much of the equipment needed for watercolor work is the same as that used for brush and ink. Information given in that section on the choice of brushes, palettes and water containers applies to the watercolorist too.

Paint Of the various forms of watercolor, most of us are familiar with the dried pans or cakes, usually supplied in boxes. The same colors, though wetter, can be obtained in tubes and in bottles as 'concentrated liquid watercolor'.

As with brushes, it would seem that in general price reflects quality. Paints labeled 'artist's' quality are recommended. Cheaper paints, usually sold in boxes, are not permanent and tend to be fugitive, not keeping their color.

The cost of artist's quality paints is often a reflection of the raw material used for the pigment – ultramarine, an indispensable color, is made from the precious gem lapis lazuli. Some are hand-ground, also incurring expense.

Left: Acrylic paint comes in tubes which need to be sealed carefully as alcohol-based acrylic paint dries very fast. Mat and gloss media can be added to acrylic paint to alter its finish.

Below: Gouache paint comes in tubes or bottles. A cheaper, less permanent version is poster paint, usually sold in small jars. There is another way to make gouache though. Mix moist watercolor paint with Chinese white. The result will be the same.

Right: Watercolor paints can be obtained in dried cakes or moist in tubes or bottles. Tubes are easier to mix if large quantities are required. But many watercolorists prefer the ease with which you can flit from color to color in a box of dried cakes. Many cartoonists use bottles of liquid concentrated watercolor which can be used straight from the bottle or mixed with each other to obtain the required color.

Laying a wash is, without a doubt, the most important watercolor technique. The aim is to leave a large flat area of color – the sky, say – with no brushmarks showing. Always mix enough paint to cover the whole area before you start.

Below: Use a good quality brush to lay the color. When covering large areas it is quicker to use a large brush. But a smaller brush is sometimes easier to manage.

Right: A flat-look finish is achieved by going repeatedly back and forth with the same mixture. Keep loading the brush and maintain an even pressure to prevent brush lines.

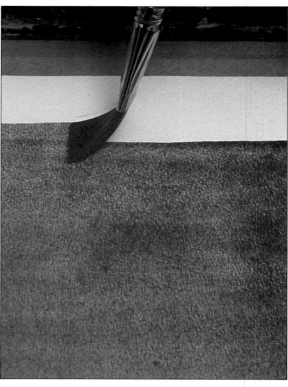

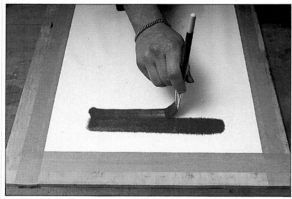

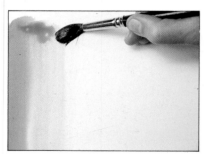

Laying a graded wash: Loading the brush with water while adding color will give graduated tones.

When nearing the end, squeeze the brush and mop up excess water to stop color spreading.

The finished effect here gives the graduated tone of blue you would expect to see in the sky.

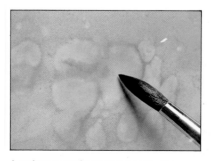 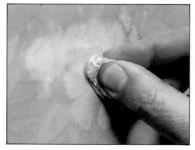

Laying a variegated wash: Drop a second color on to the first and control bleeding with the brush.

A piece of rag or tissue can be used to dry and lighten an area of the wash.

Adding black pen-and-ink lines to the picture when the wash is dry gives a hard edge.

What type of watercolors should you buy? Pans and cakes attract some artists as the palette is ready laid out making it easy to flit from one color to another when mixing. The colors are quickly cleaned with a wet brush and are easily activated if they dry up.

Tube paints can be squeezed on to a palette like acrylic or oil paints to mix required colors, but this can involve wastage. Tubes of paint tend to dry out and excavating the paint is a messy process. Tube paint though is softer to mix and saves your brush some wear and tear.

The liquid, concentrated watercolor in bottles is the choice of many cartoonists. The colors can be mixed and diluted easily, using the pipette tops the bottles are supplied with, and yet the concentration is ready mixed for cartoons where restricted color is briefed or where more simple flat areas of color are required.

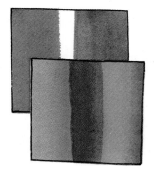

Techniques

Watercolor is a tricky medium to become an expert in, but some impressive techniques can be easily mastered to produce interesting effects. First of all, get to know the idiosyncracies of the colors in your palette. Try mixing them to see which colors predominate when dry. Paint each color on to some paper and then wash it to see which colors stain well.

Tone Watercolor is a useful medium with which to express tone, to indicate shape and form, mood and lighting. Shape and form can be expressed simply through line, although watercolor is not usually used for linear work as it is non-waterproof and has a tendency to bleed, causing a fuzzy line. Some cartoonists however aspire to such fuzziness, so do not dismiss it.

The shadows in your cartoons, which express the shape of a person or object, can be made by various dilutions of tonal wash. You can practice applying these to increase the feeling of three-dimensionality using linear cartoons in an old magazine. Build up the layers in the darker parts, leaving the lighter parts free of paint or with only one or two washes. Try doing this with diluted black paint first. Most cartoons are printed in black and white so it will not be wasted time. Afterwards add color.

If too much paint has been applied (and you are using a watercolor paper), the intensity can be reduced by cleaning it off with pure water. Gently stroke the area with a clean brush and then blot it with absorbent paper. Highlights for the purist can be made in dark areas when the paint is dry by scratching the paper surface with a pointed blade.

Wash The most significant watercolor technique is undoubtedly the flat wash. This is a brushed-on area of color or tone with no variations – the aim is all-over flatness with no brushmarks showing. Follow the instructions opposite.

A graduated wash is performed in the same way using premixed bands of one color of graded intensity. This produces a wash smoothly graded from dark to light. A variegated wash uses bands of different colors instead of tones.

Other techniques such as stippling, splattering, dry brush, scumbling and so on, are mainly used in a cartoon to suggest texture. Try them out and see how a dry brush can turn a plain coat into a fur one; how stippling can change a clean-shaven man into one with a six o'clock shadow. (See page 38-9 for ideas.)

Gouache

Gouache, otherwise known as body color, is watercolor paint with the addition of white pigment. This makes the paint heavier to handle but gives it flat, mat covering power, particularly suitable for reproduction – especially for magazine work and illustration. There are many advantages of this opacity. It means you can paint light over dark, making it useful for detailed cartoon work – particularly for adding highlights to watercolor or ink work. Its masking quality makes it

Top: Watercolor is translucent – one color will show another. Here they mix in the middle because the second color was applied when the first was not quite dry.
Above: Gouache is opaque. One color can be put on top of another without the first color showing through.

Left: An example of a cartoon using watercolor to good effect. The mixing of color in the sky gives the sun a glow. Definition is given by adding a hard black silhouette later.

Graduated color with gouache. The blue is mixed down on the palette and the paper.

With watercolor two washes can be gradually merged together over an area.

Another technique that can be employed is to drop concentrated color on wet paint.

very simple to remedy mistakes or make changes at any stage with the addition of another coat of paint.

Gouache equipment

The same basic equipment is needed as for watercolor and brush and ink. **Paints** A wide-range of colors can be obtained in tubes or bottles. Poster or powder paints, which are technically gouache, are not recommended for permanent painting. The pigment in gouache paint is ground thicker than for watercolor, yet perfectly usable gouache paint can be made by mixing Chinese white with watercolor paint. It is then possible to control the opacity.

Technique

If you are familiar with watercolors, you will find working with gouache strange at first. The paint is creamier and you will find it does not lend itself to the dilute wash style of watercolor. Gouache is particularly recommended for cartoons with flat areas of color.

Gouache is not absorbed by the paper to the extent that watercolor is, so that with a thin brush an incisive line can be produced.

For details in a cartoon, gouache is particularly useful. An area can be worked over several times, although if the paint gets too thick it may crack or flake.

Acrylic

Acrylic paint – made from pigment suspended in synthetic resin – has certain properties which make it very useful for the cartoon artist. It dries quickly to a hard, yet pliant, skin which is waterproof. Technically, it is a very flexible medium; mixed with water, it has many of the characteristics of watercolor – yet, being waterproof, washes can be overlaid without mixing with each other.

Here the blue is merged gradually into the green using gouache.

Red was added when the blue was dry, then the top edge was merged with a wet brush.

Green watercolor has been added before the yellow background is completely dry.

Gouache and acrylic applied together give an interesting texture.

Gouache can be applied with a dry brush too. Here blue paint is put on white paper.

An intersting effect with washes – red was dropped on wet paper and mopped up.

The brush has been loaded with water to soften the hard edge of the color.

Color is dropped on to wet paper which is tilted to make the color run.

Undiluted, or mixed with white, it has some of the covering power of gouache and yet the malleability of the paint means an area can be reworked umpteen times without fear of the paint cracking or flaking.

Acrylic equipment

The same brushes and equipment, detailed on page 23, can be used with acrylic paint. Most artists consider however that acrylic paint shortens the life of a brush. Extra care is needed to clean out particles of paint from the bristle by washing with soap and water. If the paint hardens, soak the brush for 24 hours in wood alcohol then rinse and wash it. Artists usually keep a separate set of brushes for acrylic work.

Paints There are various makes of acrylic paint to choose from, all with slightly different textures. The more expensive ranges have an impressive list of new chemically-composed colors.

It is worth trying one or two out. Painters using acrylics claim that fewer colors are needed in the palette as so many colors can be mixed through superimposing layers of transparent glazes. A similar selection to that given on page 34 will be useful.

Additives

There are various additives to mix with acrylics which greatly add to the variety of effects possible with these paints. The addition of different acrylic media make it possible to choose mat or glossy finishes. Transparent glaze added to the paint gives it a translucence. To help with the flow of a wash or to counteract a non-porous paper, add water-tension breaker. Finally, the addition of a retarder will stop the paint drying so fast. All these additives are available at art material retailers.

Other materials

As cartooning is an arm of the graphics field, one should be aware of some of the available aids which can help you in the final execution of your work. The materials mentioned and illustrated here, however, are not all indispensable aids for the cartoonist but are described to show you what is available and what might be useful.

Basic tool-kit
Every cartoonist needs a basic kit without which it is hard to operate effectively. A scalpel knife and its larger relation the craft knife, both with interchangeable blades, are essential for easy trimming of paper and for highlighting and correction work. A metal rule, to use with your knife, will save you ruining non-metal rulers and put off the day when you need to invest in a guillotine. A decent pair of scissors is also necessary.

CHECKLIST

Below: Not all these materials are essential for the cartoonist's tool-kit. Start by selecting the items which are appropriate to your technique.

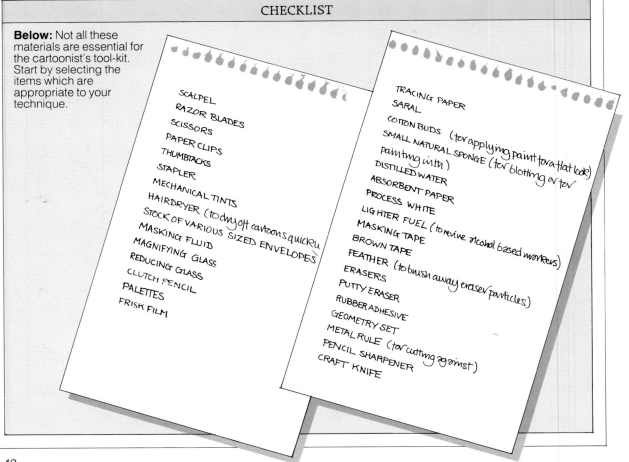

SCALPEL
RAZOR BLADES
SCISSORS
PAPER CLIPS
THUMBTACKS
STAPLER
MECHANICAL TINTS
HAIRDRYER (to dry off cartoons quickly)
STOCK OF VARIOUS SIZED ENVELOPES
MASKING FLUID
MAGNIFYING GLASS
REDUCING GLASS
CLUTCH PENCIL
PALETTES
FRISK FILM

TRACING PAPER
SARAL
COTTON BUDS (for applying paint for a flat look)
SMALL NATURAL SPONGE (for blotting or for painting with)
DISTILLED WATER
ABSORBENT PAPER
PROCESS WHITE
LIGHTER FUEL (to revive alcohol based markers)
MASKING TAPE
BROWN TAPE
FEATHER (to brush away eraser particles)
ERASERS
PUTTY ERASER
RUBBER ADHESIVE
GEOMETRY SET
METAL RULE (for cutting against)
PENCIL SHARPENER
CRAFT KNIFE

Masking tape and masking fluid are useful aids. They allow you to be slapdash with the color – and still end up with a clean, neat finish.
Below: Masking tape was used to give a sharp edge along the bottom of the background and masking fluid was used to produce the white snowflakes and the figure

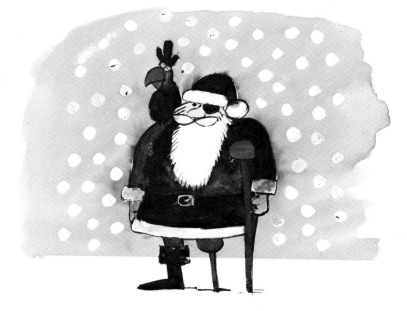

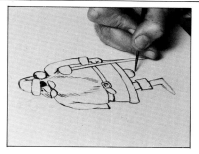

1. First, the black outline of Santa Claus is applied with pen and ink.

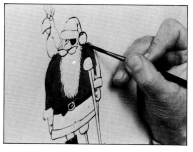

2. Then his red coat is painted in to make him look like a real Santa Claus.

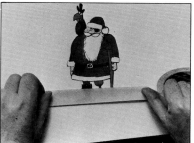

3. The masking tape is then applied along the bottom of the horizon line.

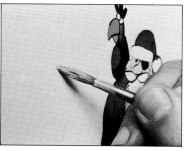

4. Next the masking fluid is painted over the figure and on the background for snow.

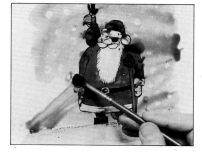

5. The colored background wash is then applied to the whole of the picture.

6. Once the wash has dried, the masking tape can be removed to leave a sharp line.

7. The masking fluid can be removed with a putty eraser or pulled away by hand.

8. The figure can then be cleaned up with an eraser to get rid of any remaining scraps.

A small set of drawing instruments can be very useful; a cheap, well-made set will be adequate. The set should comprise dividers, a pair of compasses (able to take both pen and pencil) and a set square.

Rubber adhesive is in constant use as are brown tape and double-sided tape.

When using a putty eraser, the end can be twisted into a point which can be used to erase neatly in awkward corners.

Mechanical tints
Dry transfer sheets are available in a huge range of mechanical tints – a 'mechanical' method of applying shadow or tone to your cartoon. The tints come in their various percentage grades but you should acquire the maker's reference catalog which will show you their complete range so that you can easily compare and choose.

Tracing materials
Tracing paper or 'Saral' is useful for transferring work from one page to another. Saral is like transparent carbon paper and is available in five colors. 'Graphite' is the usual choice but white and yellow are available for tracing on to colored surfaces. The traced line can be erased. The traditional method using tracing paper is more messy, but some cartoonists prefer it. Here, the outline is traced, then the paper is reversed and the outline is scribbled over back and forth with a soft pencil. When the paper is again reversed and the outline is retraced, the image will come through on the paper beneath.

Airbrush
This is a very sensitive instrument which takes practice to master effectively. Basically, it works with compressed air which forces paint (often gouache or ink) through a pen-like nozzle so that the liquid is atomized. The direction and force of the airbrush can be manipulated to produce delicate tonal work. It is also useful for blocking in flat areas of color. As a style it is presently fashionable but the airbrush is an expensive piece of equipment.

To try out some of the effects possible with an airbrush, aerosol cans of paint are available and some makes of felt tip pen produce an airbrush attachment too. These will be cruder than the actual instrument, but they will give you the feel of the instrument and give you a chance to judge whether you are interested in this aspect of painting and wish to find out more about it.

Erasing
Erasing is an art in itself and one which is worth studying if time and money – in time and materials – are of essence.

Different media require different methods of erasing as do the various supports. Sometimes the method chosen will depend on whether you are trying to erase a small mistake or a large area because you have changed your mind and want to redraw.

The media dealt with in this book will now be discussed in this context.

Ink Mistakes or unwanted blobs can be removed immediately – that is before the ink has time to dry – by sopping up as much as possible with blotting or tissue paper and then brushing over with clean water. Keep repeating the operation until the ink has been removed or the paper surface is in jeopardy. Alternatively a scalpel knife blade can be gently scraped across the offending blob. This works particularly well on thicker papers and boards.

If the ink has dried, the simplest course of action is to paint on process white. When dry, you can redraw your line if necessary.

Alcohol-based inks Felt and fiber tip pens which use alcohol-based inks are difficult to erase. Process white is not effective here, but grey gouache can be used to touch up a line and correct minor mistakes.

Right: Mechanical tints come in a complete range of grades, percentages, dots, lines, hatching, cross-hatching and other random and not so random patterns. Look in any graphic supplier's catalog for the variety of tints available.

1. Before applying the mechanical tint, first ink in the outline of your sketch.

2. Lay the sheet of mechanical tint over the area and roughly cut out shape.

3. Lift the cutaway area of the mechanical tint away from its backing sheet.

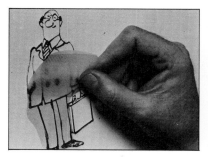

4. Place it back on the drawing board in the right position and semi-burnish it.

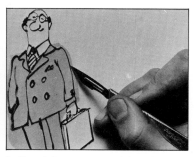

5. Carefully cut around the black ink outline of the area of tint that is required.

6. Cut out detail inside the area of the tint carefully with the point of a scalpel.

7. Burnish the tint and apply a second tint to give double density if required.

The first airbrush was patented by the British artist Charles Burdick in 1893. These days, though, there are many different types on the market. But they all work on the same principle. Compressed air passes through a venturi. This is a narrow passage that opens out into a broader channel. The expanding air creates a partial vacuum which sucks the paint up from its reservoir. The paint mixes with the air and is atomized. The spray then passes out through a conical cap, on to the surface being painted. There are several different sources of air — an aerosol can, a foot pump, a refillable cylinder or an electric compressor. The compressor is best because it gives a more constant pressure, but it is also more expensive and it is unlikely that a cartoonist would need something that sophisticated. A more simple, less expensive airbrush should be adequate. After all, the cartoonist's approach is usually a little more spontaneous and primitive than the fine artist's.

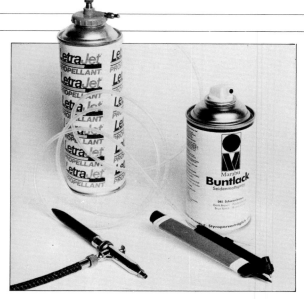

The airbrush can be used to paint a broad, but well-controlled straight line.

Masking tape can be used to give a hard edge to a smooth area of color.

This is the effect you get once paint has been applied with an airbrush and the tape removed.

More complex effects can be created by masking with Frisk film and cutting shapes out of it.

Softer edges can be made by holding a card a little distance away from the paper.

Different effects are given by turning the air pressure down until the paint splatters or varying the distance from the surface.

Pencil Use the softest eraser you can find to avoid damaging the paper surface. Rub gently and keep a clean feather to hand to brush off the eraser particles. Any brush or pen work on top of a pencil sketch should be quite dry before any attempt to remove the pencil is made.

For delicate erasing, a putty eraser is recommended. This can be kneaded into any shape required, including a point.

Charcoal A putty eraser can be pressed on to charcoal to lift it off the paper surface. Otherwise, a very soft eraser is effective.

Colored pencils Some makes can be erased but normally it is difficult. Removal with a scalpel might be tried or process white could be used to retouch, but it will not withstand overdrawing.

Watercolor It is difficult to get back to a pristine paper once the paint has been applied, but usually much of the pigment can be removed using the method described above for ink. Wash the offending area with water, allow it to sink in, activate the pigment gently with a brush, lift off, rinse, then repeat. When dry, the paper can be repainted. Otherwise, process white can be used.

METHODS OF ERASING

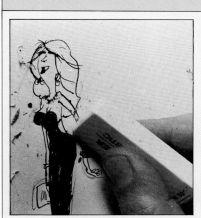

If a large area needs to be erased or cleaned, use an ordinary india eraser.

Scraping with a scalpel point can be used to clean around the detail.

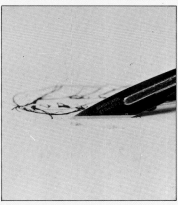

Using the flat of the scalpel blade, you can sweep a larger area clean.

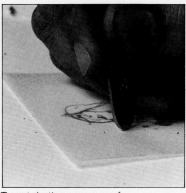

To retain the paper surface, cover with tracing paper and burnish with scalpel holder.

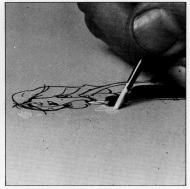

Painting around the outline with process white will make the black lines stand out.

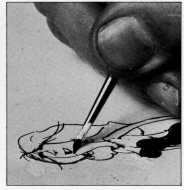

And finally, the black outline should be retouched where disturbed by cleansing.

Mixed media

The media discussed so far in this book have been examined for the individual characteristics which make them particularly suitable for certain effects. In passing, some of the more obvious media combinations have been mentioned, such as pen and ink line with a watercolor wash. Try mixing your media in less conventional ways – it may lead to a particular effect which will give your style individuality. In the same way, if a certain combination leads to an odd effect, even if it is not what you intended, use it – if not immediately, store it for future use. For example, this cartoonist once applied gouache on top of ink. It looked great. But when it was sprayed with fixative the gouache formed into droplets which was infuriating at the time, but is an effect which has been recreated many times since.

The cartoon below shows how some of the special effects discussed can be put to use. It must be added that such a multitude of different media would not be practical in a working cartoon. But, as a glance at the cartoon shelf of any library will show you, anything goes.

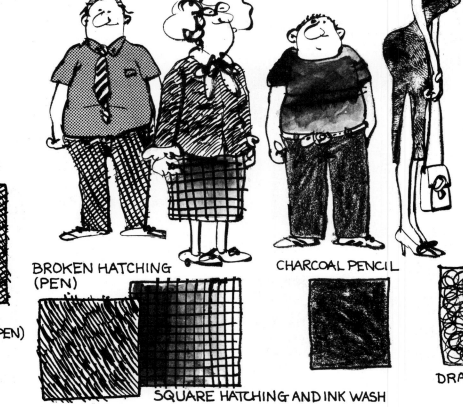

MECHANICAL TINT

IRREGULAR
CROSS HATCH (PEN)

BROKEN HATCHING
(PEN)

CHARCOAL PENCIL

SQUARE HATCHING AND INK WASH

DRAF

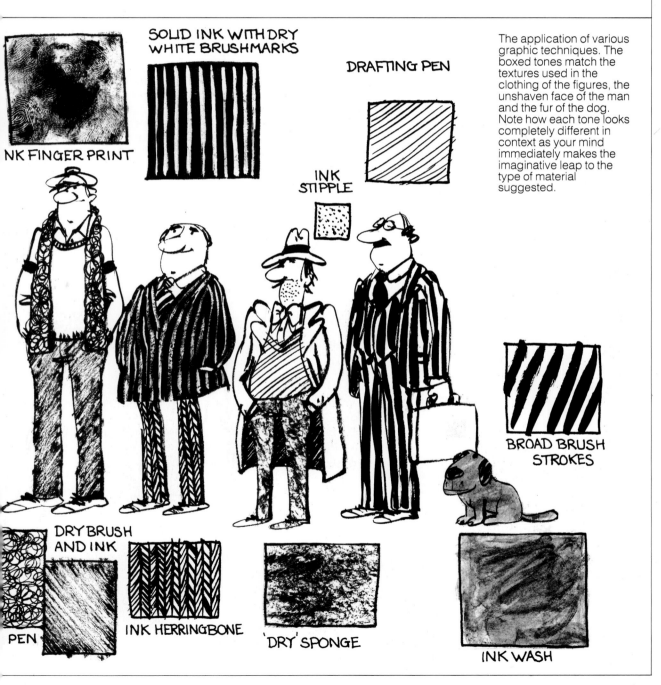

NK FINGER PRINT

SOLID INK WITH DRY WHITE BRUSHMARKS

DRAFTING PEN

INK STIPPLE

The application of various graphic techniques. The boxed tones match the textures used in the clothing of the figures, the unshaven face of the man and the fur of the dog. Note how each tone looks completely different in context as your mind immediately makes the imaginative leap to the type of material suggested.

BROAD BRUSH STROKES

DRY BRUSH AND INK

PEN

INK HERRINGBONE

'DRY' SPONGE

INK WASH

Surfaces

There are a host of different papers to choose from – different weights (thicknesses), textures, finishes and colors. Paper is sold by the sheet, in a block or pad or in packets of a certain number of sheets. Sometimes the materials you use to draw cartoons and your style will influence your choice of paper, but the eventual goal of your cartoon is important too.

Working paper
A packet (500 sheets) of A4 white 'typing' or offset paper is recommended for everyone, but particularly if you are aiming for the 'gag' market when you will be sending off cartoons to various editors. Most cartoonists submit their work on this paper so that the editor can easily flip through a sheaf of cartoons the same size. Using such paper will also keep your mailing costs at a reasonable level.

Layout pads (A3) are another good buy. They are useful not only for rough scribbles but for finished drawings, although, as it is thinner than 'typing' paper, it would be advisable to stick it on to thicker paper before submitting it to an editor. Use of such paper for finished drawings would, however, influence your choice of materials because ink washes, watercolor, and gouache tend to buckle it. Pencil, ink outline and felt and fiber tip pens work best with layout paper.

Drawing paper
These are manufactured by machine in three variations: hot-pressed, not and rough. The more absorbent, often cheaper, papers will produce a bleeding line which, on the whole, you will be trying to avoid. They will also distintegrate when wet and tend to yellow with age. For a sharp line a hard surfaced paper will produce the best results. The more expensive cartridge papers allow for correction and reworking.

Hot-pressed has a reasonably hard, smooth surface and is mainly used for pen and ink wash and pencil.

Not paper (meaning 'not hot-pressed') has a more textured finish which is more suitable for soft-pencil work, gouache watercolor and ink wash.

Rough paper comes in various degrees of roughness and thickness and can be used with all the media discussed. It usually needs to be stretched before work begins.

Illustration boards
These are sheets of paper with a board backing and come in various thicknesses and textures. Some illustrators find them good to work with and they are easy to handle (and difficult to damage). CS10 is commonly found to be the best all-rounder. However, they are expensive and cannot be used with some printing methods. So, unless you are required to use them for a particular job, they should be avoided.

Tinted papers
These can be used for certain illustration work or a wash of color can be applied to white paper before work commences.

Paper for watercolor should always be stretched. Watercolor causes unstretched paper to buckle.
Top: Soak the paper carefully in clean water.
Above: Cut lengths of tape to match each side of the drawing board. Drain the paper, place it flat on the board, watermark uppermost, and stick the dampened tape along each side. insert a thumbtack into each corner of the board. Leave the paper to dry naturally.

1. Layout paper for line work with pencil or magic marker.
2. Paste/line board for line work with pen and ink.
3. Line board for pen-and-ink and brush line work.
4. CS10 – good for pen and ink, washes, airbrush, color crayons and any general use.
5. Cartridge paper for pen and ink work. It will also take washes.
6. Tinted paper which can be used with pen and ink and color crayons. Process white can also be used to give highlights.
7. Watercolor paper which will take pen and ink, washes and watercolor.
8. A4 typing paper for rough sketches. It also provides a convenient format to present your work to newspaper and magazine editors.

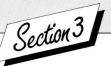
Evolving a style

A FLIP THROUGH any humorous magazine will demonstrate the disparity of style acceptable for publication today. No more is the pure, sharp line deemed perfect and to be aspired to. One look at Ralph Steadman's wicked pen, which scratches and blots its way through life, and you will see that it is almost fashionable to be messy. But, of course, there is more to it than that; Steadman's style is his signature, one which he evolved over some time, but it is acceptable because he uses it to produce highly original, piercing cartoons. So, although an autographic style is desirable, it must be combined with original ideas too.

Another road to a personal style is through the development of your own cartoon character. To do this, however, you will have to study and analyse the human figure, learning to crystallize it into a few expressive strokes. You will need to know a few characters too, so keep your eyes and ears alert. Monitor the work of your fellow cartoonists and see what you can learn from them.

Now it is time to get drawing. First of all tackle figures as they populate most cartoons; then backgrounds, props and details. A brief look at compositional tips, lettering and color and before you know it you are considering ways of bursting into print. And that is how it should be. This is the cartoonist's way of knowing that he is doing it right. And, hard as it might be to take the rejections – and all cartoonists have to – you must keep testing your work in the market.

Ideas and inspiration

Having reviewed the materials and techniques available to the cartoonist, work must begin. The prospect of putting pen to paper is daunting to most of us. But, in a relaxed atmosphere, you will have no trouble in starting out. First, therefore, you must find a conducive place to draw, so that those ideas can percolate and the cartoons roll.

Where to work
A budding cartoonist does not have to have a special place to create cartoons; finished cartoons are generally small in area, so space is not a prerequisite for their execution. But where you choose to draw must have the right 'feel' for you – it might be at the kitchen table surrounded by howling kids or perhaps you will find the garden shed more inspiring. But, of course, the ideal situation is to have your own desk in some corner, or a room to yourself, for your own organized chaos.
Equipment It is not usually necessary to buy special furniture but a professional

Where you work will depend on where you feel happy and at ease. You may only feel happy in a large space overlooking a captivating view as above. But perhaps this would give you agoraphobia and you may prefer the bustle of the kitchen table. If working at home disagrees with you, try renting space in a graphic design studio, if possible close to your main source of work.

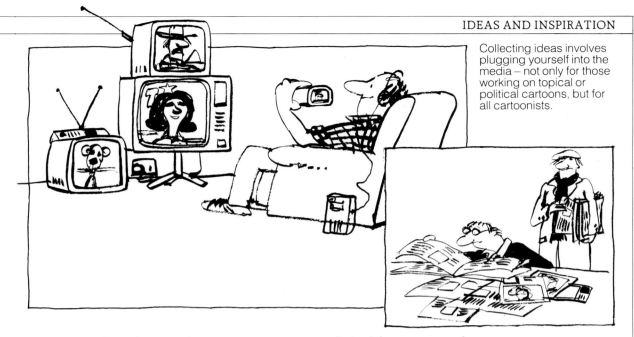

Collecting ideas involves plugging yourself into the media – not only for those working on topical or political cartoons, but for all cartoonists.

cartoonist will need to consider certain equipment to make his life easier. A good sized flat table or desk is essential. A draftsman's desk with adjustable angle is the perfect choice but is certainly not a must. Whatever surface you use, you will find a drawing board useful for certain techniques. It also makes it easier to alternate between jobs.

Your work surface should be positioned if possible by a window, ideally facing south (the most constant light). You will also need an adjustable lamp to give extra light even during daylight.

Next, you will have to look at your chair. Any chair will do, you will think, but if you intend to spend hours in your chair, it is worth considering investing in an adjustable, swivel-seated chair with a back support.

Apart from these items, shelving for your books and references is useful and a plan chest with ample drawers is very handy (though not essential initially). You will find it ideal for storing paper and those returned rejected cartoons which dog the working cartoonist. Finally, for those visual references which become useless once misplaced, consider a filing cabinet.

Your 'think tank' As this is your 'think tank', and it is often a lonely job, make your surroundings as comfortable as you can. Have a telephone extension installed for briefings. Then commandeer an easy chair for that brainstorming session and the endless drinking of cups of coffee.

A radio will provide you with musical inspiration and, for the political cartoonist, news bulletins. In fact the radio enables you to keep in touch with the world outside and is a constant source of ideas.

Studio space If you have no room at home or if you find you cannot work there, an alternative is to rent desk space in a graphic-design studio. This will have all the facilities you may need and can also be a source of unexpected work. Find one in a location preferably within easy access of your main areas of work.

Collecting ideas

Where does a cartoonist get his ideas from? The answer is anywhere and everywhere. Of course, it depends a little on the particular branch of cartooning you wish to pursue. A political cartoonist will naturally need to listen and watch news bulletins and read the newspapers. But radio, television and the news-papers are sources of ideas for all cartoonists. Keep your eyes and ears in

The sketchbook is the cartoonist's most important tool. To breathe life and vitality into the subjects tackled, it is important the cartoonists studies facial expressions, body postures, touching contrasts and everyday scenes. Although this knowledge will not be put to the same end as the studies of a fine artist, it is important to develop similar disciplines. This commitment will always show in your work.

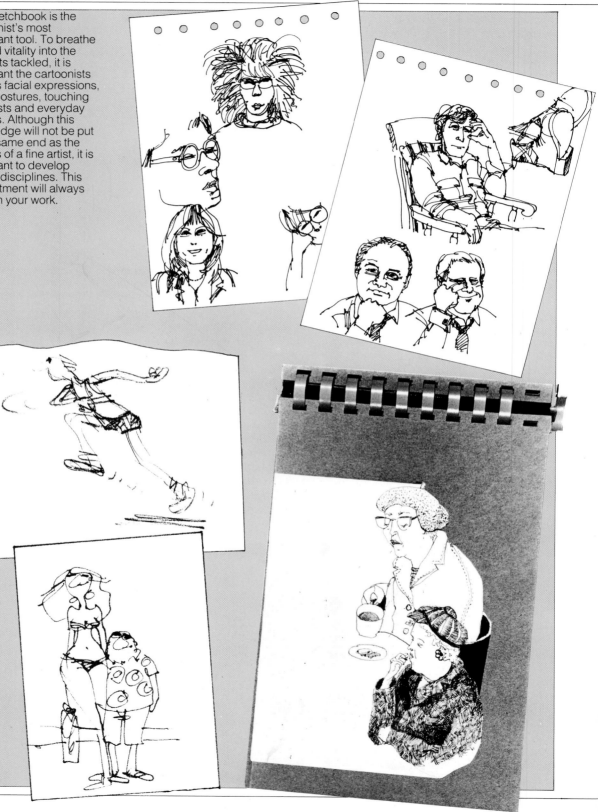

overdrive. The last section of this book will give you a hint of some of the more recognized categories of cartoon subject but, as by now you will realize, there is no reason why you should not initiate a new one.

Be aware of what people are talking about. Watch them, observing quirky situations and details, expressive gestures, facial expressions. Listen to conversations – bus and train journeys are a particularly rich source of ideas.

Then, of course, there are the humorous magazines filled with the work of your fellow cartoonists. This is essential fodder and is useful for tips about style as well as being a catalyst for ideas.

Finally you will find that most cartoonists express ideas on subjects they really know about. If you do not have specialist knowledge, then do as many have done before and start with cartoons about the home or work where humorous possibilities are infinite.

Sketchbook

Once you have sharpened your senses, you will find ideas for cartoons will come flooding in; they have no respect for the hour of day or tact with regard to place or situation. So it is useful to keep a small sketchbook and pencil or pen on your person at all times. You will find it indispensable not only for those brilliant ideas that strike you half-way through the night, in the bathtub or on the bus, but also for recording interesting characters, details, textures – ideas to store for use in the future.

Carrying a sketchbook about with you also means that time need never be wasted. Stuck in a traffic jam, train is late or cat needs to be taken to the vet, well you can be working on ideas.

Of course, you might claim that any paper will do such as the back of a used envelope. Yes it will, but such paper gets lost or thrown away. So, unless you can train those around you to respect them, a sketchbook will act as a filing system for your ideas and a source of inspiration on those blank days which come to us all.

When choosing a sketchbook, bear in mind what medium you intend to use with it. A good quality paper should take pen or pencil without difficulty and will make the book something worth keeping as a record of your observations. You can either start at the beginning of the book and work your way through or, for easier reference, sub-divide the book into different areas – for example, written ideas, figure drawing, background detail.

If you are sketching with color work in mind, color notes can be made in words. It also makes future browsing through old sketchbooks more amusing if a record of the date and place of each sketch is kept.

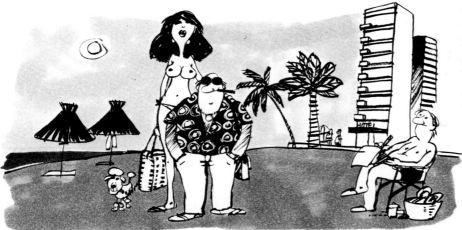

You never know where you will come across material for your cartoons. You may find characters, details, situations and textures on the street, in bars or even when you're on vacation. Always carry a sketchbook so you can store them for future use.

The cartoon figure

The cartoon figure, like its prototype, comes in all shapes and sizes. This line up gives some idea of the diversity of the human shape, showing how figure types can be caricatured. Many of them are stereotypes you will recognize – the voluptuous beauty queen, the macho all-American football player. To come up with a cartoon figure, isolate one essential characteristic and exaggerate it.

Figure drawing has to be recognized as an important aspect of the cartoonist's art – you will not find many cartoons without figures. So it is essential to study the figure in detail to see how best you can manipulate it to suit your needs. With each character, the cartoonist has to distill expression, physical type and accoutrements to produce a figure with as much visual economy as possible. This takes practice but building up your own rogues' gallery of characters is an amusing occupation.

Physical features

Perhaps some general points about the human figure would be useful even though cartoon figures are always a caricature, making generalizations almost impossible. Just one look at the line-up below will demonstrate that classical theories on proportion are there to be scoffed at.

Fatties and thinnies Many of the characters depicted below are either tall and thin or short and fat, which is very much the cartooning norm. The tall thin types have stretched out heads and necks and long skinny legs but their torsos are the same length as the fatties. The latter group have squatter heads, no necks to speak of and short legs. In each case you will notice that the arms, even though

this means grossly stretching them in the case of the tall guys, respect reality – the elbow is at the waist and the relaxed fingers reach down half-way between the groin and knee.

Male and female What about the differences between male and female figures? As you will see below, unless you need to depict an aggressively female character, the more obvious female distinctions – breasts, broad curving hips, *et cetera* – can almost be ignored. You will see there is not so much physical difference between the female tennis player and male volley ball player apart from the female chest being in parenthesis. Yet it is obvious what sex they are because of their clothing and their hair and such small details as the tennis player's earrings and the way she stands.

If, however, you are depicting a Tarzan then the male characteristics will need to be exaggerated: broad shoulders, narrow hips and bulging muscles. And Jane would have exaggerated breasts, rounded hips and a waspy waist.

Facial character

From some generalities, let us now look at the particular. A face can tell you so much about its owner. Not only whether she or he is young or old, pretty or ugly,

The human face tells us a great deal about its owner – whether they are male or female, old or young, pretty or ugly, intelligent or stupid, fat or thin. Here are a selection of faces that are instantly recognizable from everyday life. You don't need to be told any more about these characters. The face alone says it all.

OBSERVE RACIAL CHARACTERISTICS

SUNGLASSES AND JEWELRY ADD SOPHISTICATION

ADDING SHADOW OR STUBBLE MAKES THEM LOOK TOUGHER

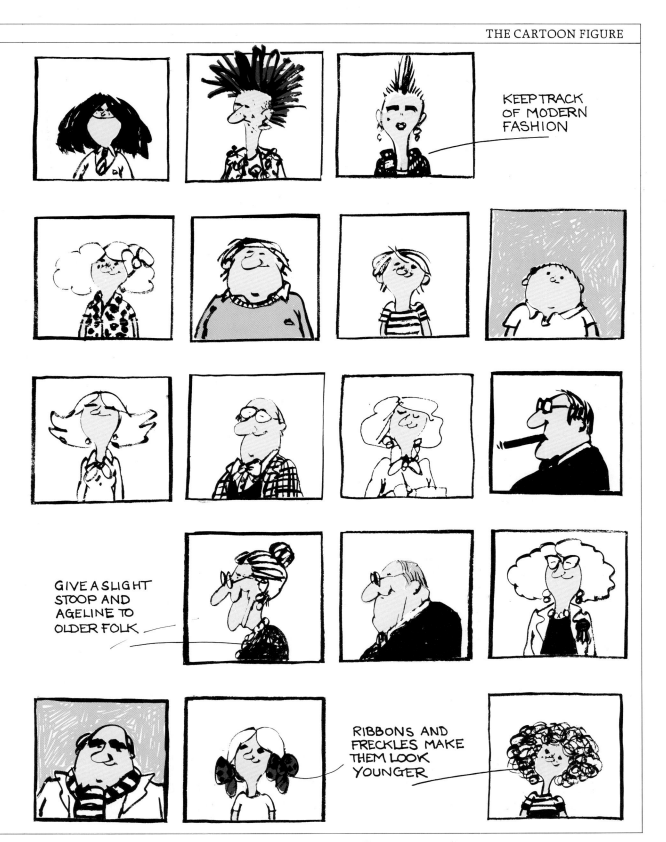

KEEP TRACK
OF MODERN
FASHION

GIVE A SLIGHT
STOOP AND
AGELINE TO
OLDER FOLK

RIBBONS AND
FRECKLES MAKE
THEM LOOK
YOUNGER

Practice drawing your cartoon characters from all angles. Your figure will not always be staring out of the frame, full face. Once you have mastered the art of visualizing your characters in the round, you will find that your cartoons become more lively.

but often whether they are aggressive or timid, stupid or clever and much about their feelings. Before we even meet a person, we will judge them on their appearance alone.

The cartoonist must take advantage of this human reaction and use particular facial features and types to create their characters. A business man will be fat and bald and wear glasses; the secretary will be young and glamorous, so she will have long fair hair. Corny stereotypes, but instantly recognizable.

A glance at any chance group of humans will remind you of the discrepancies between facial features. Get used to observing people in the street and use your sketchbook to record unusual, as well as typical, physiognomies.

Age You will notice certain facial characteristics associated with age. A very young child's features are crowded into the center of the face. A child's head is larger in proportion to his body than is an adult's. An elderly person will often be smaller in stature, have a bigger nose and hollow cheeks.

Hair Hairstyles too are a great indicator of age and of personalities. You will notice in the characterizations above, the facial features are not hugely different – it is the hairstyle which often makes the character. A beard or a moustache can obviously greatly change a man's face.

Facial expression

The point of a cartoon is often made through facial expression. You cannot afford to let the reader miss the point, so your depiction of this inner feeling will need to be exaggerated – a caricature of what it is in reality. A drunk, for example, can be depicted with concentric circles as eyes and an undulating line for a mouth.

Collecting examples You are your best model in this case. You will need to study yourself in a mirror, contorting your face into various expressions. See what your eyes and mouth in particular are up to when you laugh, are angry or

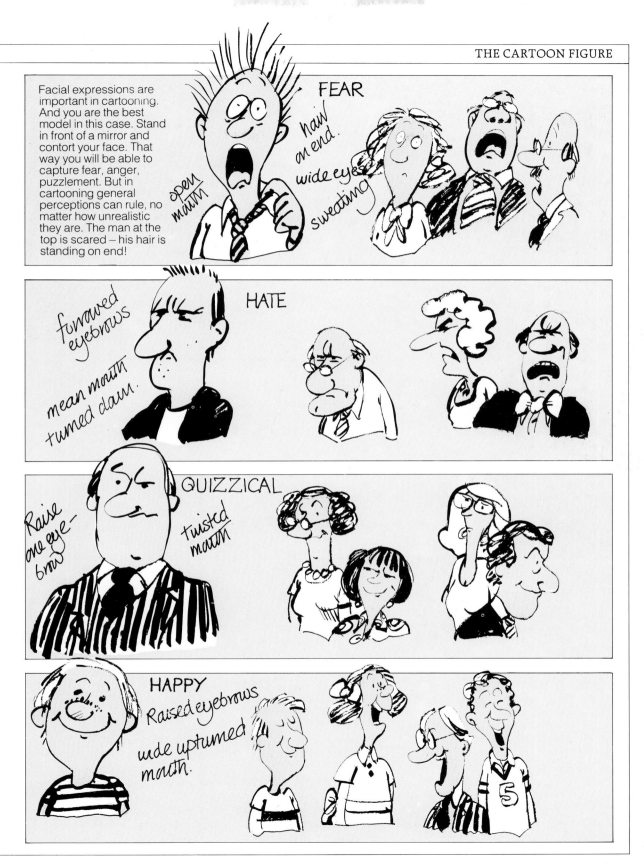

Facial expressions are important in cartooning. And you are the best model in this case. Stand in front of a mirror and contort your face. That way you will be able to capture fear, anger, puzzlement. But in cartooning general perceptions can rule, no matter how unrealistic they are. The man at the top is scared – his hair is standing on end!

FEAR

hair on end.

wide eyes

sweating

open mouth

HATE

furrowed eyebrows

mean mouth turned down.

QUIZZICAL

Raise one eye-brow

twisted mouth

HAPPY

Raised eyebrows

wide upturned mouth.

Hands are very expressive of character. And they are always of prime interest to the artist. If you look at the selection here, borrowed from some well known cartoonists, you will see how they can vary. Sometimes they bear little relationship to the hands we know in real life.

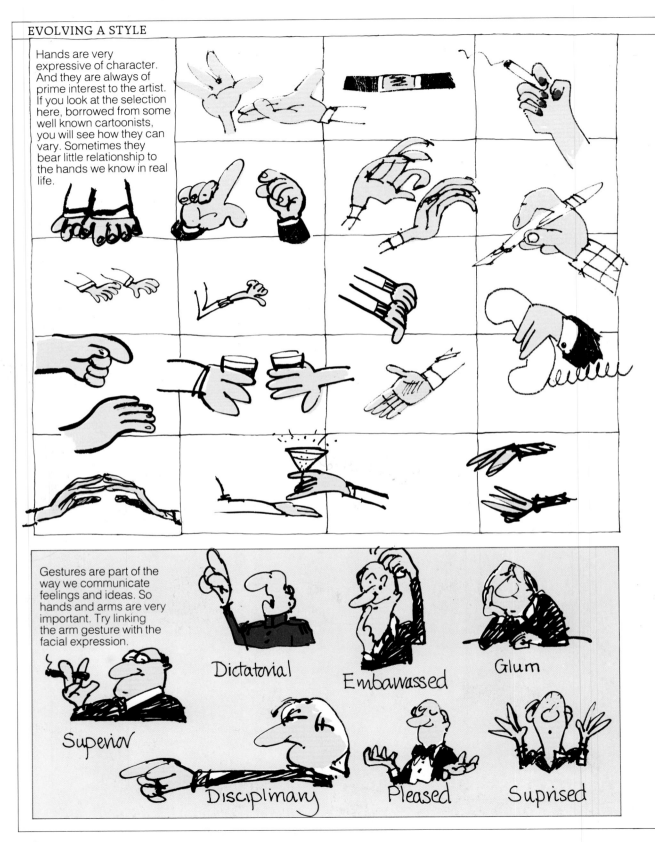

Gestures are part of the way we communicate feelings and ideas. So hands and arms are very important. Try linking the arm gesture with the facial expression.

Dictatorial

Embarrassed

Glum

Superior

Disciplinary

Pleased

Suprised

62

frightened. Sketch the results in simple ovals to start with and then transfer them to some of the characters you have created. You will find certain expressions seem to suit certain characters – another facet of the stereotype.

One expression you will have to study if you are going to be in the 'gag' market is the talking face. Who is it who is making the punch line? This needs to be obvious and it is the open speaking mouth which can lead the eye to the center of the action.

Hands and feet

There are other means of expressing character, for instance through hands and feet. By looking at examples drawn by other cartoonists, you will see that the appendages on the ends of arms and legs sometimes bear little relationship to the hands and feet we know.

Hands Following the lead given by Walt Disney and his Mickey Mouse, many cartoonists have adopted the three-fingered hand, finding it less complicated and cumbersome and easier to manipulate. The fact that this extraction is rarely noticed shows how far the cartoonist can go in depicting the essence of what he sees rather than the actuality.

Try out some expansive gestures with hands. Put them to their favorite uses – shaking other hands, scratching heads, holding glasses, cigarettes. Practise linking them with some of the facial expressions so that they convey the feelings of enjoyment, anger or fright.

Feet Feet, and particularly footwear, are an important feature of cartoon characterization. The distortions they suffer through the whims of the cartoonist are often hilarious. Different types of footwear are, however, very expressive of age, type and profession.

One important point to note about feet is how the heel of the foot, and

Feet are a very important part of the human body. Some of these feet you will recognize from well known cartoon characters. Note how the heel bulges out behind the line of the back of the leg. Also note how people stand with their feet at an angle, like a clock saying ten to two. Their legs are wider apart if the character is fat. And the legs are parallel if the character is seated. Remember, too, that footwear can pin down a character as easily as a hairstyle.

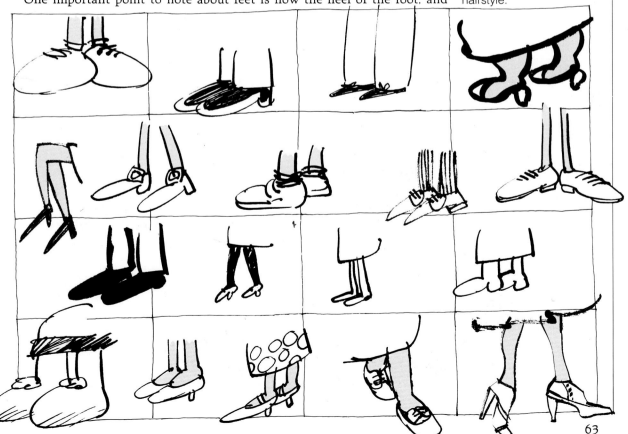

Clothing is essential in building your characters but a single prop can summarize character. Many of these will seem almost too obvious. But the reader has to take in the situation in a split second, so all the signs must be very clear.

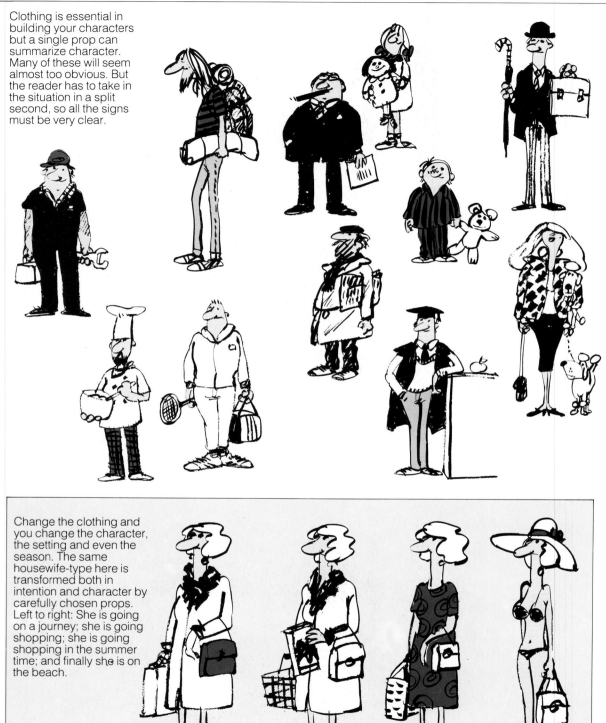

Change the clothing and you change the character, the setting and even the season. The same housewife-type here is transformed both in intention and character by carefully chosen props. Left to right: She is going on a journey; she is going shopping; she is going shopping in the summer time; and finally she is on the beach.

therefore shoe, protrudes out behind the back of the leg. Once you start looking you will notice there are a number of common stances – with the feet splayed at ten to two. Look and see how the feet are placed when a person is sitting down – usually flat on the floor, parallel to each other. A more difficult exercise is to try and match the stance of the feet to the facial and hand expressions already attempted to express laughter, anger and fright.

Complete figure

Now that you have studied the details, it is time to fit the pieces together into the complete figure. This can be a daunting task and the feeling is to try and secrete part of the figure – behind a desk, amongst vegetation. Eventually, however, you will have to break out.

Keep your figures simple. Try to crystallize the image into as few strokes as possible. Most cartoonists sketch the figure in pencil, refining the line until the solution is reached. Then the outline is inked in confident strokes following the pencil guidelines.

Do not be afraid to copy other cartoonists work for practice. Copying will help you achieve a confident fluid line as well as bringing into focus certain details which otherwise might go unnoticed. The assimilation of a variety of styles will also help you towards evolving your own.

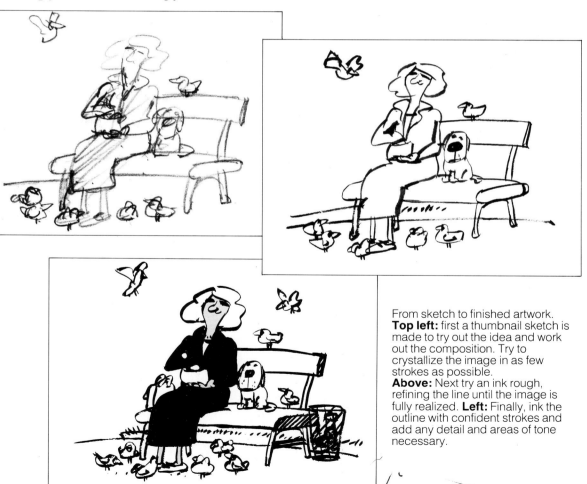

From sketch to finished artwork. **Top left:** first a thumbnail sketch is made to try out the idea and work out the composition. Try to crystallize the image in as few strokes as possible.
Above: Next try an ink rough, refining the line until the image is fully realized. **Left:** Finally, ink the outline with confident strokes and add any detail and areas of tone necessary.

Caricature

Bill Hewison's sequence of work on a cartoon for *Punch* with notes from the author.

By now you will have realized that the art of cartooning is very much that of caricature – caricature of character, expression, feelings, clothes, props. The art is in analyzing the subject matter, condensing the information and mentally selecting what is important and/or different about what you see. This you grab with both hands and exaggerate, the rest you treat cursorily or ignore.

But caricature means more to us than this. It concerns capturing the likeness of a person known to us – often a celebrity – and through distorting their features and mannerisms a clear element of ridicule emerges. Caricature can often develop into a vicious sport.

Portrait studies
How are these skills acquired? It would be reasonable to assert that in ordinary cartooning a fair degree of competence can be achieved from a limited amount of drawing ability. For caricature the demands are stronger. A certain amount of straight, observed drawing is necessary, so practice searching portrait studies of any friend or member of the family who is prepared to sit still for half an hour. The hand will acquire facility, but, more important, the eye will be trained to observe and analyze. If you cannot hijack a live model, practice with photographs. Some cartoonists prefer to work from photographs though I personally find it easier with the real thing.

Exaggeration
The next step would be to take one of these 'studies' and seek out those idiosyncratic personal elements upon which the caricature will depend, putting them down very simply in a new drawing. If the nose is prominent, make it enormous; if it is not very significant, make it tiny. Are the eyes like slits, or little currants, or are they large and droopy-lidded? Make them more so. And what about that lop-sided/pinched/fleshy/cavernous mouth? Exaggerate.

Hair The hair line and hair style is very important. For instance, if your target has

'**Left:** The sketch-book notes were drawn using live models, in this case three actors on stage during an evening performance. My view was from a seat in the stalls and I needed to gather as much visual information as possible so that I could eventually draw these actors from memory.
'**Right:** Later on, at the drawing-board, I worked out a composition which would fit a predetermined space.'

'The finished caricature, drawn in my studio, as it appeared in *Punch*. It shows Bruch MacVittie, J. J. Johnston and Al Pacino in the stage performance of *American Buffalo*, and is one of the caricatures I draw each week to accompany the drama review pages. I try to exaggerate not only the facial characteristics but also the actors' expressions, their bodies and their gestures. The subjects' eyes are very important; get those right and you are well on the way. The junk shop setting for *American Buffalo* was interesting to draw but it also provided me with a textured background which helped to link the three men within the composition. At other times, depending on the occasion, I have used parody, symbolism, and a more comical style – partly for variety, partly in order to reflect my own reaction to the play.'

a shallow forehead, start the hairline just above the eyebrows.

Accessories Accessories can be useful in nailing the likeness too. Spectacles vary enormously in shape and size. If the face wearing them is small, cover it almost totally with the spectacles; if it is round and fat reduce the spectacles to a mere excrescence on the bridge of the nose. Earrings, likewise, can dominate a caricature.

Distinguishing marks Do not fail to spot the obvious. The cartoonist has a free pass to include anything he sees – warts and all. Warts or a beauty spot you might find are the only distinguishing features so they can be strategically employed.

Bodies Then there are the bodies. Caricature traditionally focuses on the heads of its victims, leaving the rest of them as an attenuated appendage. But difficulties are met when the subject turns out to be a tall and skinny pin-head. These are his essential characteristics; therefore he must be drawn skinnier and taller. In my own work, I discovered that you could still keep the head fairly prominent, but to achieve the slim, tall effect you kept the torso small but drew the arms and legs very long and thin, making the length of leg *below* the knee much longer than the length *above* it. This is a technique which always seems to work.

Mannerisms Finally, be aware of a person's mannerisms. The way they hold a cigarette can be highly individual. Do they gesticulate a lot or keep their hands in their pockets? How do they stand – with their feet well apart and equal weight distribution or with their weight more on one leg?

Putting it together

After practice and a build-up of confidence, you should take any one of your successful caricatures and re-draw it quickly and loosely, over and over again, using, say, a wax pencil, then a piece of charcoal, then a brush with ink. This will improve facility and you will discover which medium suits you best.

I would advise against meticulously copying other people's caricatures no matter how much you admire them. At the end of the day to be a successful caricaturist you have to do your own analysis and you should get in the habit of doing that right from the start.

Elizabeth Taylor as she appeared on the stage in London in *Little Foxes*.

ANTHROPOM
WHAT'S IT?

Anthropomorphism

Part of the line-up of characters from page 56/57 is reproduced here. But it has been transformed by replacing the heads with those of certain animals. Certain animals, because of characteristics associated with their species, lend themselves well to such antics.

T his means giving human attributes things other than people. It can apply to an apple which is given human features, arms and legs, or to an animal. Some cartoonists find it easier to express themselves through animated inanimate objects or through animals. And in a way it is a short cut into a humorous situation – a television with a face for a screen and a definite character is immediately created.

Animals
Many cartoon animals are just an extension of human figure drawing. But if you are knowledgable about animals and enjoy drawing them as they were meant to be, you will find many cartooning precedents.
Naturalism The joke in a naturalistic cartoon lies in the human speech and thinking process attributed to the animal. Even though your elephant or crow will resemble its natural self, you will need to simplify the form, capture the recognizable attitude – in effect caricature it.
Human animal To be able to draw these half-human half-animal figures you will need to be able to draw humans and animals. The degree of humanization is up to you. You can put a dog on his hind legs, dress him in a suit, hat and dark glasses.

Like humans, animals can be used to represent different types. **Right:** In this line-up we have boss cat, grandpa cat, cuti-cat and way-out cat. **Below:** Different breeds of dogs are often associated with human types too. Similarly birds can be drawn to depict certain character traits.

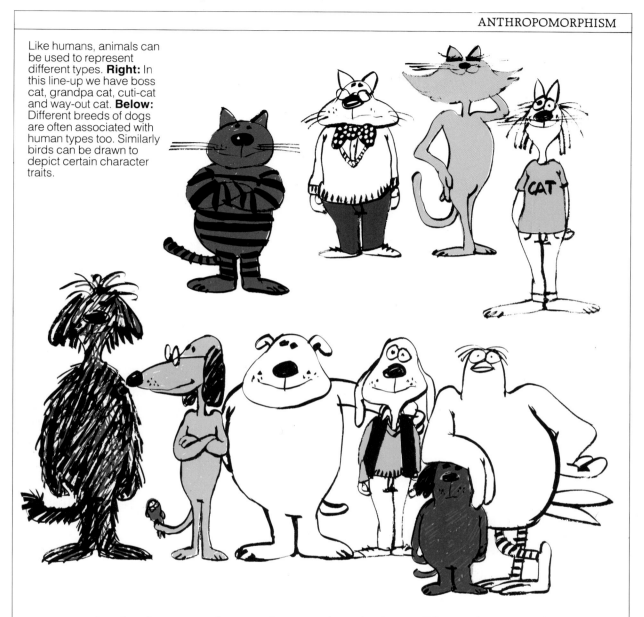

You can give him hands or paws. Alternatively you can keep the dog on all fours but give him human facial expressions.

Animal types Animals are as easily type-cast as humans – the slow tortoise, the lion as king, the aggressive bulldog. These characteristics can be useful in composing your cartoon. A human situation can be depicted using different animal types. As you will see on the facing page, you might replace the humans with their human equivalents.

Inanimate objects

You can give anything human attributes. Once you start, it can provide lively entertainment. Try drawing what is on the table in front of you: books, coffee mug, scissors – before you know it you will have a cast of actors set upon a stage. You will be surprised how quickly these objects acquire characters with just a few strokes of the pen.

Inanimate objects can be given the anthropomorphic treatment too.

Movement and sound

Among all the information that it is necessary to cram into a cartoon, you will often need to include hints at what has just happened and what is just about to happen. This can be done in many different ways but capturing your character mid-movement will suggest these things. Being able to depict movement and its relation to non-verbalized sound is a necessary talent that a cartoonist should acquire.

Movement
Fortunately, there are a host of 'tricks of the trade' which will quickly add a touch of professionalism to your work.

'Whiz lines' These are rather like the vapor trails an airplane leaves in a clear blue sky; they show where the object in motion has been and give an indication of speed. Whiz lines need not be straight; they can show a crazed path with various altercations that have taken place en route. Whiz lines take practice. They need to be done in one stroke, and with confidence but without too much pressure.

Movement echoes These little lines indicate movement backward and forward or up and down, echoing the movement of the object. A man jumping will seem to be in motion if strategic parts of his body are repeated above and below his outline as though a blurred photograph of his jumping had been taken. A dog's tail can be shown to be wagging in this way, with small diminishing parallel lines either side of the tail.

Defying gravity A feeling of speed and movement is given if movements which occur are exaggerated. A person or an animal running is always depicted well off the ground. This can most easily be indicated by drawing a shadow some distance below the figure.

A person will be straining forward so that the head is no longer above the feet

From the top: The dog is standing stock still. He lowers his head and sniffs the ground. He lifts up his leg and leans forward. Then he barks. **Right:** Whiz lines and the movement echoes around his body give him movement. The impression of speed is re-inforced by lifting him off the ground and by depicting his ears flapping in the wind.

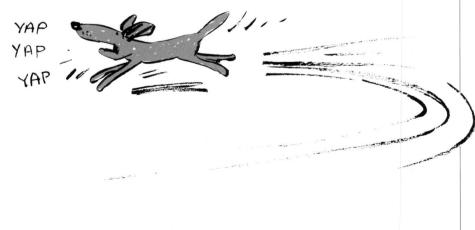

YAP
YAP
YAP

An illusion of a potentially happy domestic breakfast scene is shattered by a knock-on effect of dramatic movement, coupled with the impression of deafening sound.

in an impossible position, but it does not look that way. Animals are depicted with their legs stretched out to impossible limits or with legs crossed in the middle. Do not forget more traditional methods of showing movement such as swept back hair or animal ears, drapery flapping in the wind, or trees bent double.

Sound

Sometimes you will want to indicate sound in your cartoon without recourse to speech bubbles. You might need a shouting, gesticulating, drowning man in the background of your drawing. An open mouth will of course signify sound; this can then find expression in lines radiating from the head.

But what about inanimate objects? If they make a noise, they vibrate and it is this vibration and its possible effect if magnified that the cartoonist tries to represent. If you shook a telephone, the handset would eventually fall off its cradle; so it is this effect which the cartoonist depicts when drawing a ringing telephone.

To represent a telephone ringing, the cartoonist exaggerates the process involved. The vibration of the bell inside appears as the whole phone shaking.

Setting the scene

N ow we have to set the scene by providing our figures with a few props. By looking at the work of other cartoonists you will notice that props can be reduced to an essential minimum. Alternatively, if detail amuses you, you can crowd your cartoon with intricate yet relevant objects. Every object included, however, must be considered as to its relevance in the composition. Then, those objects you have selected must be stripped of unnecessary detail. A telephone, for example, can be reduced to a few strokes – a circle for a dial (if it is the old-fashioned type). You do not need to include the cable – unless it is about to trip someone up, that is.

Professions
Setting the scene involves more analytical work. If you look at your desk, it will no doubt be littered with objects. But which of these would you include if you wanted to depict a cartoonist?

Luckily a lot of the work has been done for you. There are well recognized props for certain professions. The business man, psychiatrist and insurance

The same scene is being played out, only the scenery is different.
Right: The husband returns home from work in a working class house. household.
Opposite: The husband returns home from work in a middle-class household. The flowered wallpaper and the ducks on the wall may be clichés – as are the stripped wall paper and packed book shelves – but these props set the scene instantly.

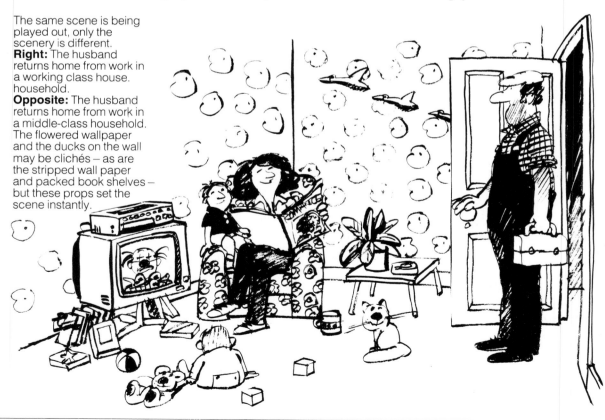

man all sit at an office desk but the business man might be smoking a cigar and he will have a graph on his wall; the psychiatrist will have his couch and possibly a certificate showing membership of his professional body on the wall; the insurance man will have a certificate and his company's name on the door.

Social distinctions
You will need to be able to encapsulate a social setting with a few props. Television and advertising use this kind of scene setting: the millionaire with his swimming pool and fast cars; the Duke with his butler, dogs and a room full of paintings by Rubens; the middle-class home with all its appliances; and the blue-collar worker and his dozen children and their associated debris. Sometimes unkind, often untrue, but always well recognized generalizations.

Interior exterior?
It is often easier and less confusing to place your figures in an interior setting, but, if your interest lies in the great outdoors, use your knowledge in your work. The

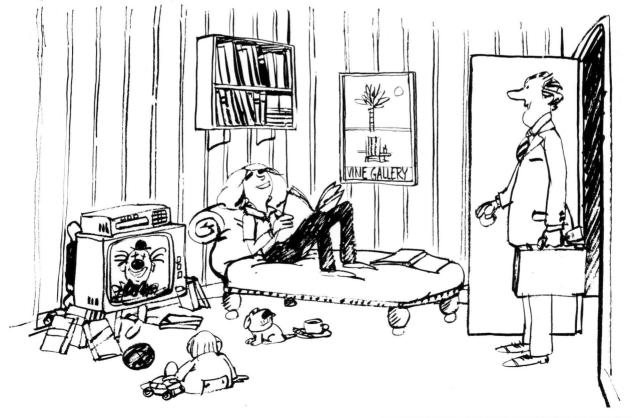

Don't throw away old magazines until you have combed them for useful reference material. Cut out and keep pictures of historic buildings, famous people, cars, interesting props, topical and newsworthy items – like

Concorde or the Sinclair C5, uniforms, interesting poses, exotic settings and anything that might come in handy when drawing a cartoon. File them in folders so that you can find them easily when you need to refer to them.

Above: The wide-angled lens used to take this interior shot lends wonderful perspective to the drawing of this interior. **Below:** It is easy to forget where things are placed in a bar. Reference material helps.

effects of weather and the time of day provide an interesting dimension to an exterior setting. Windows are obviously useful in an interior to inform you of such details going on in the outside world. Or clothing can be indicative, for example, a wet raincoat, umbrella and galoshes on a character who has just been admitted into the room.

Refining down your image

Not only are objects refined down to an essential representation of the whole but details and textures are too. You will notice that when a cartoonist draws a brick wall, he will seldom draw in all the bricks. A sample corner of the whole will be shown to be made of bricks and the viewer's eye does the rest – filling in the blank space with bricks. The brain supplies this additional information in a split second with one glance at the cartoon.

You can apply this method of shorthand throughout a cartoon – an area of grass can be indicated by a few blades, a wooden door by a couple of knots, and so on.

The neon signs, the style of the buildings and the harsh shadows all say this is America. It is hard to create this sense of place off the top of your head.

Note the random arrangement of goods in the window and the old fashioned shop sign.

These details are elusive if you don't have a picture to follow.

The details of the thatch and the shape of the tree are taken direct from the photograph.

General background props which give a cartoon instant placement. These can be picked up from other cartoonists, but it is always best to go back and study the real thing for yourself before attempting to draw it.

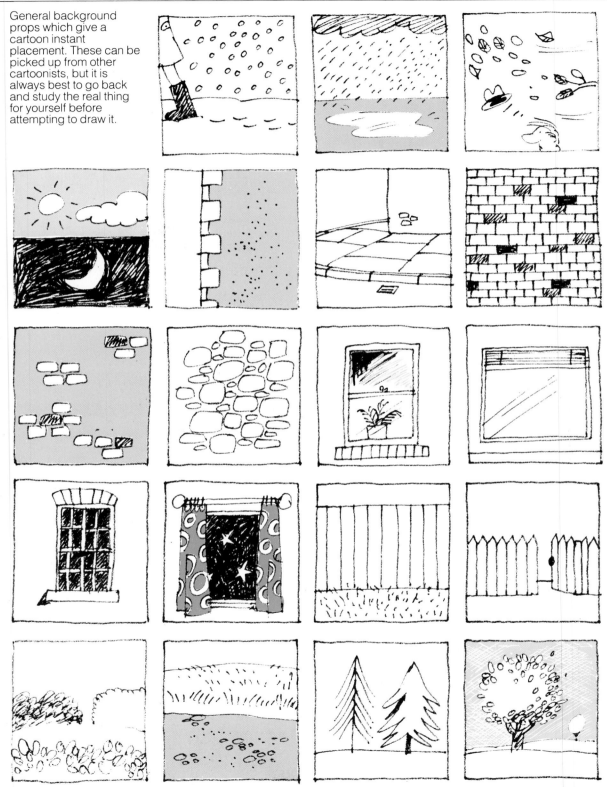

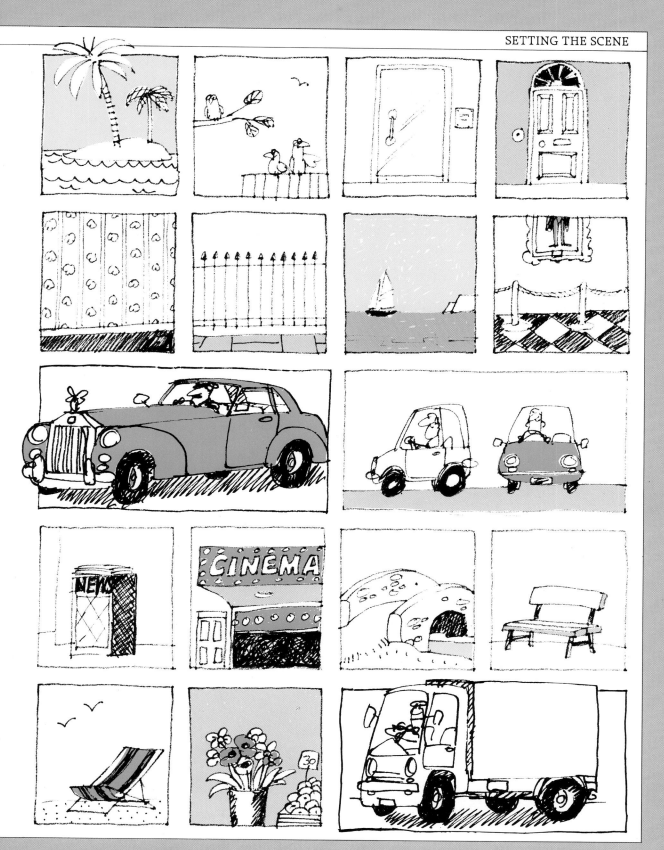

Lettering

The gag cartoonist will not need to spend much time on lettering, but for those in the strip business it can be a laborious and time-consuming occupation. The caption under a gag cartoon is usually set separately by the printer, so you can either write or type it clearly under the cartoon. For any other lettering within the cartoon, your handwriting will be sufficient. As long as it is neat, even and legible. There are various styles of script you can use to convey different meanings. Perhaps you might select square plain capitals for the a glass office door, through which you can read – backwards – 'J. Jones, Literary Agent' which sets the scene. But you might choose a different script for 'cyan' inscribed round a black bottle. It is useful to obtain a book on calligraphy from which these different styles can be copied. Sometimes dry transfer lettering can be effective.

Different lettering gives different effects. But if you are not aiming to make a particular point, use your own handwriting – as long as it is legible – retouching if necessary. It will match your style of cartooning better.

Strip cartoons
For the amateur the job of filling in the speech balloons can be fun. If, however, you are producing yards of cartoons, it can become tedious. So, most profession-al strip cartoonists leave this job to a letter artist. For those of you intending to do your own, here are some tips.

What to use A pen or brush and ink are most commonly used for lettering. But you can use whatever suits you. A typewriter can be depended upon to produce a clear legible script. Some, however, regard any form of mechanically produced

Five easy steps to perfect lettering. First, rough out the words with pencil on layout paper so you can see how they will look and work out the line breaks. Then draw parallel pencil lines the height of the letters you are going to use, plus a center line if you are going to center the text. Rough in the letters, then go over with ink. Draw the bubble with a template. Erase pencil lines with eraser and touch out any ink smudges with correction fluid.

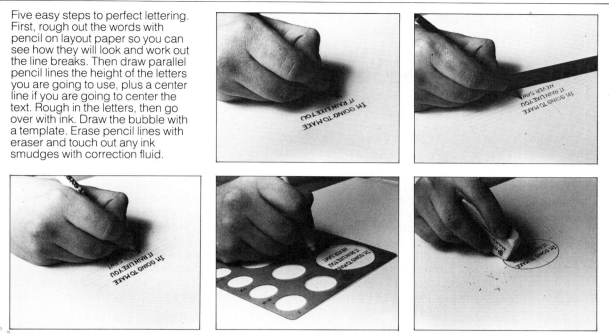

lettering as stiff and inhuman, spoiling the appearance and 'feel' of the cartoon. As a rule, cartoonists tend to use what they have used in the cartoon.

If you cannot rely on the regularity of your own hand, yet you want it to appear hand-lettered, it is possible to obtain stencils or templates, some of which are for use with a special pen.

Method First of all you have to decide what you want your character to say. This must be clear and concise and no more than two short sentences. Then you will need to break these up into lines as they will appear in the cartoon. The breaks will depend on whether you are using speech balloons or not and, if you are, what shape they are. This in turn can depend on the composition of the frame.

Now the writing: this must of course be neat and legible. The letters must be of uniform height and width with even spacing in between. The ink supply must be constant.

You will probably find it easier with capital letters throughout and this seems to be the norm. A medium grade nib or brush is usual, changing to a thicker one for bold lettering and to a thinner line for italics.

You will find it easier to regulate the size of your letters if you draw guide lines – two lines between which the letters are inscribed. A lettering triangle is useful for drawing these lines or you can obtain them as dry transfers.

There is no doubt that it takes practice to achieve even legible lettering, but do not despair, even the professional letter artists allow variations, if only to show they are human.

Speech balloons A glance at any comic strip will show you how speech balloons vary not only in size but in shape and outline. The shape and size will depend on the amount that needs to be said and on the composition of the frame.

Make sure that your balloon is not too crowded. There should be plenty of space between the outline and the lettering.

The outline can tell you something about what is inside the balloon. A jagged outline indicates a mechanically produced voice – radio or television – a balloon connected with smaller bubbles indicates thoughts rather than speech. You will find many variations in any comic.

Composition

I n a good cartoon the meaning is quickly conveyed to the reader; his eye is drawn compulsively to the center of the action. But why does this happen? Many cartoonists arrange the elements of their cartoons in a particular fashion because 'they feel right' – and sure enough the meaning is clear. But there are several methods of composition, based on traditional artistic tenets, which can help you in deciding how to organize the various elements of your cartoon coherently.

In this section, it will be demonstrated how, through the use of compositional lines, proportion, scale and perspective, you can manipulate the reader. Such jargon tends to inspire terror. But a cartoonist does not need to be an expert in such things; he simply needs to be aware of these traditional tenets – if only to be able to rebel against them.

Shape of the cartoon

One of the first considerations when composing a cartoon is the shape. Sometimes you will be briefed on a specific shape – for a newspaper, for example, it will often be a vertical rectangle, spanning a single column. Magazines tend to go for more horizontal shapes. Whichever it is, the shape will govern your composition. It need not affect the choice of your subject matter, only the way you present it. You might think of a desk as a horizontally shaped object, but as you will see from the illustration, it can be organized into a vertical shape through the careful choice of viewpoint (where you choose to view it from) and eye level (the

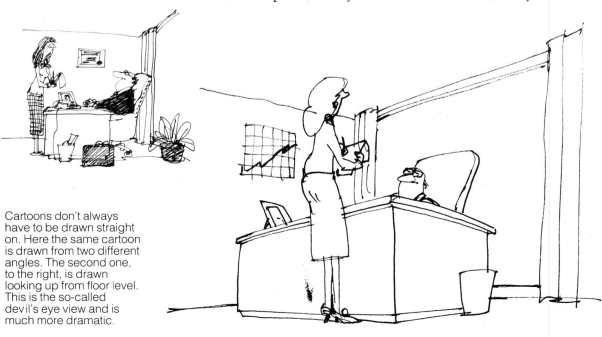

Cartoons don't always have to be drawn straight on. Here the same cartoon is drawn from two different angles. The second one, to the right, is drawn looking up from floor level. This is the so-called devil's eye view and is much more dramatic.

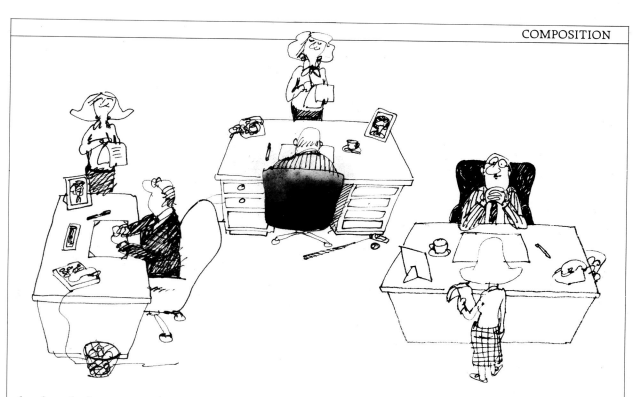

The same cartoon drawn from different points of view. The change of point of view changes the shape of the picture, but it also changes where the viewer's sympathies lie.

level at which you view it). Sometimes, you will find, however, that you compose your cartoon without any shape restriction, leaving it to the editor to decide.

Scale

When composing your cartoon, you will have to give consideration to scale. If the emphasis is on a certain character, he can be brought to the foreground, almost filling the cartoon. Or is the scenery of importance? In which case your characters can be placed in the background.

A point can be made crystal clear by distorting scale – a child standing next to an elephant will be depicted as much smaller in proportion to the elephant whose enormity will be exaggerated.

Center of interest

When a reader looks at your cartoon there is an expected sequence; he looks at the drawing first, then reads the caption, which sometimes can return him to the cartoon for a double-take. What is important is that the center of interest is clearly defined, so that the eye is led directly to it. This can be compositionally organized through a number of well tried methods.

Simplicity The cartoon is so simple, the reader cannot fail to go straight to the action.

Compositional lines The reader's eye is led to the action through compositional lines – arms, furniture, perspective features of the landscape or whatever all 'point' to the center of interest.

Hiatus Sometimes the main character or object is given prominence by being surrounded by a hiatus. The cartoonist will sometimes erase lines round the character or arrange the composition so that the characater is singled out, away from the rest of the crowd.

Tone This method is often used, where the center of interest has greater tonal contrast than the background. In a cartoon of a party, the main character will have his suit blacked in, the rest will be in pin-stripes or greys.

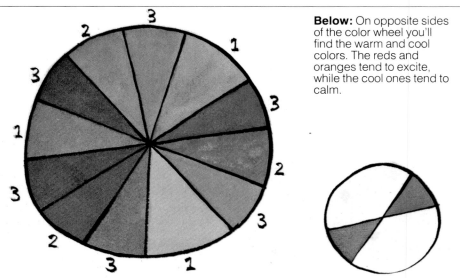

Right: When the primary hues – pure red, yellow and blue – are mixed they produce the secondary colors. And when they, in turn, are mixed with primary hues you get the tertiary colors. The relationship of these colors is often expressed by placing them around a color wheel.

Below: On opposite sides of the color wheel you'll find the warm and cool colors. The reds and oranges tend to excite, while the cool ones tend to calm.

Eye-level and viewpoint

An important aspect of composition is the eye-level. The artist must decide whether to take the eye-level of a bird or a worm or of a normal human. Your decision will not only alter the structure and shape of your composition, as you will see from the illustrations, but it will also affect the mood. The high eye-level promotes a feeling of intrusion, while the low one makes the character at the desk seem powerful and overbearing – the viewer feels small.

The viewpoint also can affect the composition, depending on whether it is set to the left, right or in the center.

Perspective

The choice of your viewpoint will also influence the type of perspective system you employ. The use of linear perspective will help you to create a feeling of three-dimensional space on a two dimensional surface. The figures and other elements of your composition can then be set within this space.

Some cartoonists and artists refuse to acknowledge the existence of such a system and claim to simply draw what they see. If you are able to do this, you are fortunate; but you might find that it is difficult to detach yourself from your preconceptions – for example, you know that the two parallel sides of a road are equidistant yet when seen from one end they recede together until they eventually meet at a point on the horizon.

Lighting and tone

Lighting and tonal contrast can be used compositionally. Strong light produces strong tonal contrasts to create an eye-catching drawing. Strong light also produces interesting shadows which can be used to manipulate compositional direction, focusing the eye on the action.

A feeling of depth in the cartoon can be induced by reducing the tonal contrast in the background and increasing it in the foreground.

Color theory

There are many styles of color cartoon, just as there are styles of cartoon; the style chosen is often determined by the printing process involved. Whatever style is intended, however, it is useful to know a little about color theory to back up what is often an instinctive approach.

Color wheel The primary hues – red, yellow and blue – when mixed produce

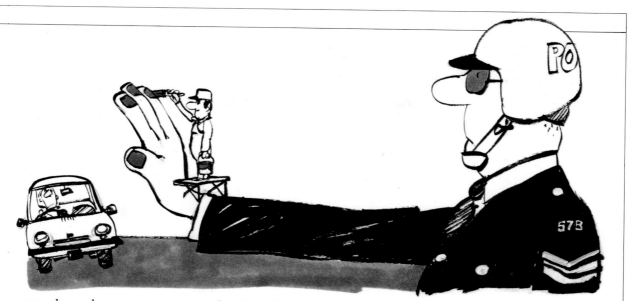

secondary colors – orange, green and violet. When these, in turn, are mixed with the primary colors, tertiary colors are formed – red-violet, violet-blue, orange-red, yellow-orange and yellow-green – and so on. There are about 150 discernible hues which can be placed round a color circle. This device beloved of color theorists is useful in demonstrating some of the properties of colors.

Warm and cool colors The color circle can be divided into warm and cool colors. The artist can select particular colors to elicit a particular response in the observer – cool blues and greens have less visual impact and induce a feeling of calm, whereas shrieking reds and oranges produce an excited response, although not always a positive one. Color can therefore be used to stimulate or placate; to induce a mood of excitement or tranquility.

Receding and advancing colors Tradition also claims that warm colors advance from the picture plane and cool colors recede. This knowledge can be used by the artist to enforce the structure of a composition. Compositional lines can be picked out and strengthened using warm advancing colors, which stand out and lead the eye to the center of the action. Alternatively, the composition can be generally colored in cool colors except for the center which is picked out in a striking color, taking the eye directly to the action.

The repetition of a strong color can also be used to lead the eye subconsciously through a complicated composition. The same ploy is used by strip cartoonists to maintain the flow from one frame to the next.

Complementary colors Colors which appear opposite each other in the color circle are said to be complementary. When complementary colors are placed side by side, they appear more vibrant. If you choose colors which are close to the primaries, they almost seem to flicker – the most electric combinations are red and green, violet and yellow, and blue and orange.

The juxtaposition of complementary colors in a composition makes it possible to draw attention to a particular object or area. This technique can also be used throughout a color piece, following the example set by the Impressionists, to give the whole composition a feeling of vibrancy thereby attracting the eye. The most dazzling effects will be produced by flat areas of color.

Weight and size The cartoonist is by now adept at taking advantage of preconceptions. It has been proved that the general public regard an object painted with a dark color as heavier than the same object painted with a light color. However, this particular preconception has to be fitted in with another – that lighter objects appear larger than darker objects of the same size.

Some cartoonists specialize in making their jokes through the use of color. This means that, should the cartoon be printed in black and white, it would not be funny – the joke *is* the color. Such cartoons need to be devised and perfected as any other gag cartoon might be.

The strip cartoon

T he humorous strip cartoon is very similar to the single-frame gag cartoon we have been dealing with so far except the story evolves over a number of frames some or all of which may contain dialog. The adventure strip is something different. It is a more complicated art form where each strip is part of an overall plot.

The strip cartoon business is big business with strips syndicated to newspapers all over the world. In this world a cartoonist is very often someone who draws the outlines of the main cartoon figures. He is fed a story by a writer; the backgrounds are filled in for him as is the color and lettering.

This may be the type of work that interests you, but our aim here is to give some guidelines to the cartoonist who wants to produce a strip cartoon in its entirety. It is, therefore, the humorous strip cartoon that we will be looking at.

Cartoon character

A strip cartoon is usually based on a cartoon character (or a group of them) invented by the cartoonist. A single sequence is seen as a self-contained episode.

The story line can unfold in several different ways, depending on the format of the strip, how many frames you have and your sense of drama. The framing can be drawn in equal widths with a ruler, at varying widths freehand, some can be missed out or you can employ jazzy shapes. Lettering can be in bubbles or floating in the frame.

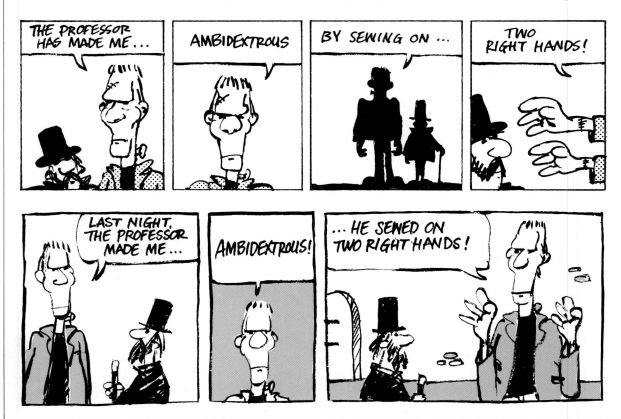

How do you invent a cartoon character? It is difficult to give precise instructions. A cartoon character just happens, usually unintentionally. It is safe to say, however, that your character needs to be modeled on someone or a type you know well – even if you represent him or her as something completely different, a dog for instance. Knowing your character well will enable you to imagine your character's reactions to the various situations you drop him or her into. These need not be contrived situations – the obvious one is often the funniest.

The story unfolds
Next you have to decide how to split up the sequence of your story into frames – known in the trade as the 'break down'. The first frame usually sets the scene, the second frame (and sometimes the third and fourth) initiates the action and the last delivers the punch line.

You will need to rough out your strip, bearing in mind the relationship between the frames. This flow in the strip can be encouraged in several ways.

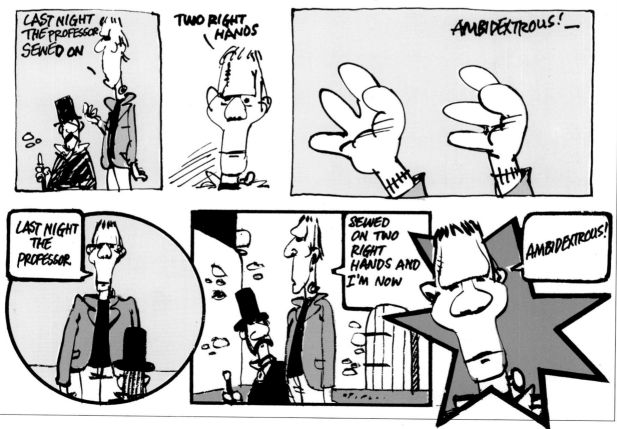

FROM FRAME TO FAME

To sell a cartoon strip to a newspaper or magazine you must make up a presentation kit. On the first page draw all the main characters. Then

draw five or six fully finished strips – a week's worth for a paper. Then you should rough out in pencil enough to keep a paper going for a month,

to show that you can keep the idea going. But if they decide to publish, you may have to keep up to a month's worth of strips finished in advance.

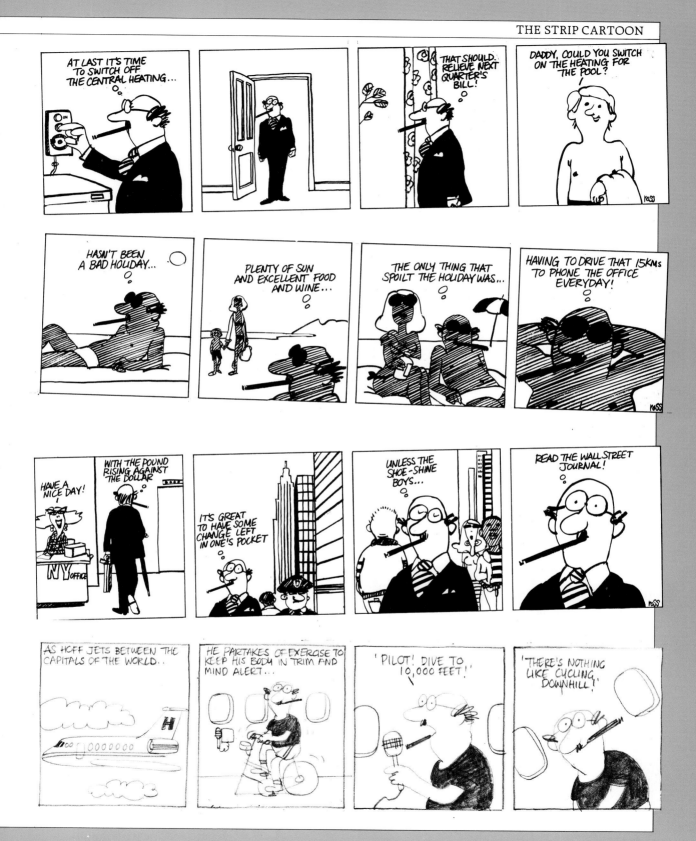

When working for a comic, a script will be sent to you by one of their regular writers. It will already be broken down into rough frames. And you should be supplied with a template from the comic. Former issues will govern the style. Pencil in each scene, then ink in the outlines and apply mechanical tints or washes, depending on the style of the publication. If the strip is in two colors, you may be required to make separations, where the color is applied on a separate sheet. When you send the strip into the publishers it will be checked by an editor, who may want you to redraw some frames – or even the whole thing! But finally, after the strip has been published, you will get your check in the mail.

APPLY MECHANICAL TINTS

POSITION OVERLAYS

OR PAINT WASHES IF NEEDED

Dialog First of all the impetus can be maintained through the dialog – the eye hurries from one speech balloon to the next.

Composition Compositional lines can lead the eye through the sequence 'pointing' out the way. This is why many cartoon strips start in the first frame with a strong vertical on the left – often a person facing to the right. This stops the eye from wandering out to the left and directs it purposefully down the gaze of the person towards the second frame.

Constants Repeating a constant in each frame is a common method of creating a follow through in your sequence. The image need not be identical, the expression can change on a person or even the position. But the same figure standing, say, on the left of each frame will very simply link the panels. This link can also be made through the repetition of color constants.

Strip variations

Strip cartoons do not have to be restricted to three or four regular frames. By looking at the work of other strip cartoonists, you will find longer and shorter strips and frames of every size and shape.

Strip cartoonists have learned a lesson from the movie cameraman. You can zoom in for a close up, change to a long shot or even change your eye level so you are peering from above in one frame and from below in the next. Such changes can cause problems with continuity and you will have to find other links to maintain

the flow from frame to frame. Such variation, however, will add excitement.

The frames can be varied too. They need not be the same size or even shape. Explosive action can be bordered with a jagged frame or a dream sequence indicated with a cloud-like border.

Composing the dialog

The dialog must be simple and in character. The joke must unfold over the length of the strip. This means that each frame must contribute to the joke.

Have fun with strip cartoon language. The POWs and WHAMs and ZAPs add to the fantasy world you can create.

If you find dialog composition difficult you might be able to link up with a writer. This is a very common situation and as long as your humor is in tune it can produce very successful cartoons.

Speech balloons and framing

Lettering and speech balloons have been dealt with in the following section. But, your choice of the shape of speech balloon can very much affect the style of your cartoon and contribute to an individual 'look'. The framing round your panel can do likewise. Some cartoonists draw their balloons with the aid of French curves and circle templates. The borders round each frame would then probably be drawn with a ruler. Others like the balloons and borders drawn freehand.

Cartoons for print

By now your cartoons will be eliciting the reaction you intend. Your friends and relations, who have been coerced into honest criticism, are beginning to recognize your caricatures and are hopefully rolling with laughter at your gag and strip cartoons. It is time to let you loose on the rest of the world.

Starting out
Most cartoonists start as amateurs which means offering your work for no financial reward just to get the kudos of seeing it in print. Be aware that involvement in the printing process is valuable experience and any opportunity should be grabbed at.

Start as early as you can. School or college magazines might be your first target but if you are past that stage, try your local newspapers and periodicals.

If you meet with apathy or insult (or both), do not be deterred, start your own publication. It need not be too ambitious. You can print using a photocopier or better still (and probably cheaper) consult a local printer who will advise you on the best method of printing to use. Whatever process you decide on, it will help you to consult a book on graphic production.

At this stage it is important to get plenty of practice and gain exposure. The more people who see your work, the more likely it is that you will be 'spotted' – by a local business man who wants to vamp up a lecture with audio-visual work or by someone in the publishing world. Offer your work, therefore, to anyone who will take it – a college campus will be a haven of opportunities but there are also local clubs and societies.

Snowball effect
With increased confidence, you can start bombarding national periodicals and newspapers. The national newspapers employ regular cartoonists on their staff but those with gag ('smile') sections are open to unsolicited cartoons.

Your local library will contain publications which list the names and addresses of all periodicals. Look at the list of trade journals too and see if any of them spark your interest or relate particularly to your work.

If you are good, your work will be accepted and before you know it you will be inundated with work. For most of us, though, it is a slow process – but persevere.

Presentation
It will help you if you present your work well. The presentation will vary slightly depending on the work, but whatever it is for, a poorly drawn cartoon smudged with grubby fingermarks will not invite consideration. Keep your work clean and present it as neatly as possible.

Gag and strip cartoons These can be presented on 'typing' paper as this helps the editor flip through a pile of 'possibles'. Do not inundate an editor with cartoons, but it is quite usual to send five or six at one time. The cartoon must be finished and as you would expect it to be printed (although it will undoubtedly be reduced – see below).

If you want your cartoons returned (should they be rejected), enclose a

It helps if you present your work neat and clean. And an editor is more likely to look at your gag cartoon if it is drawn on quarto-sized typing paper which his secretary assembles in a sheaf for him to flip through. If you want your cartoon returned enclose a stamped, addressed envelope.

A BRIEF CAN COME BY PHONE, MAIL OR BY VISITING THE CLIENT. TO START WITH YOU'LL NEED TO HUSTLE.

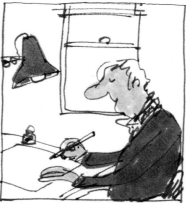

ONCE BRIEFED, THE CLIENT MAY WANT TO SEE ROUGHS OF HOW YOU ENVISAGE THE JOB. ONCE GIVEN THE OK PROCEED WITH ARTWORK.

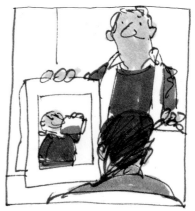

THE DAY ARRIVES WHEN YOU SUBMIT YOUR CARTOON. TAKE NOTE IF THE CLIENT HAS SPECIFIED A CERTAIN TIME HE WANTS IT DELIVERED.

BUT BE PREPARED TO DO SOME AMENDMENTS TO YOUR DRAWING ESPECIALLY IN ADVERTISING.

IF THE CHANGES ARE WITHIN REASON RETURN ARTWORK AND.....

THEN HUSTLE FOR MORE WORK AND WAIT FOR THE CHECK TO ARRIVE!

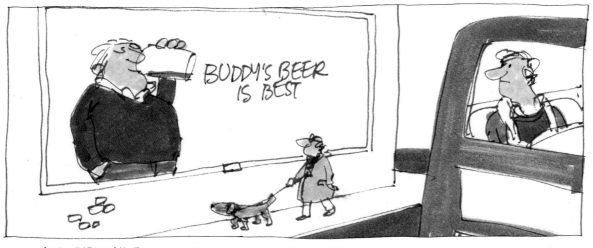

AND THEN HAVE THE SATISFACTION OF SEEING YOUR WORK ALL OVER THE PLACE!

Below: Most cartoons are reduced in size when reproduced. Reproduction nearly always improves the appearance of a drawing. It makes the lines denser and more incisive. And small imperfections vanish. Enlargement has the opposite effect. Lines become lighter and weaker. And all the imperfections are emphasized. It should be discouraged if possible. This drawing of the baffled cartoonist holding a postage stamp-sized reproduction makes the point.

Top: The charcoal line appears sketchy as it was drawn (center). When reduced (left) it is clearer, if slightly fuzzy. The enlargement makes it difficult to see it as a line though. **Above:** Much the same happens to a fine pen line.

Actual size

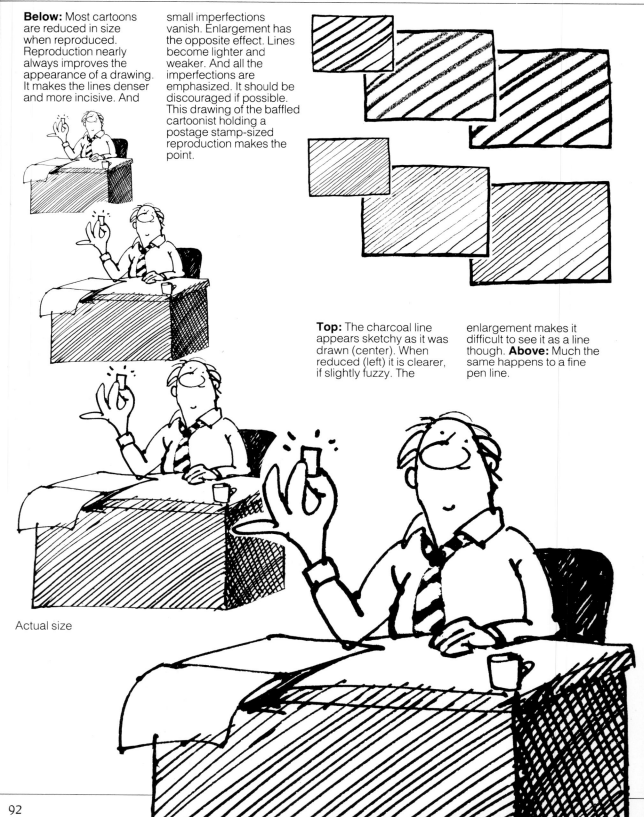

stamped, self-addressed envelope for the editor to return them in.

Commissioned work In such work for a publisher, for a special cartoon or for an advertising agency, you will be following a brief. Discuss with your editor what type of support to use and what materials. A rough will be produced which, once vetted, can be finished off, but even then you might be asked to make changes. Your final artwork should be presented in a mask and protected by a transparent cover.

Reduction and enlargement

Most cartoons are reduced. If you look at some printed cartoons, you will see they are generally smaller than one would naturally draw them. The size you draw them yourself depends on what you are happy working with. Some cartoonists produce very large cartoons on A2 paper, but mostly quarto paper is used with the cartoon taking up about half the area.

Reducing a cartoon has certain effects on it. First, the line becomes thinner, denser and sharper. A chalk or charcoal line will lose its smudginess and become

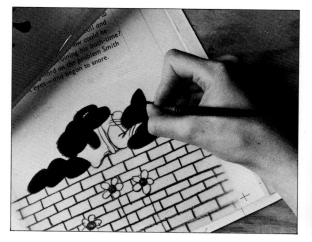

Above: A clear acetate sheet is placed over the outline and the colored areas are filled in with solid tone.
Above left: The tone can then be separated from the outline so that the second color can be printed separately in a specified color. More overlays can be added, to give other colors.
Right: The cartoon printed with the second color printed on top of the first.

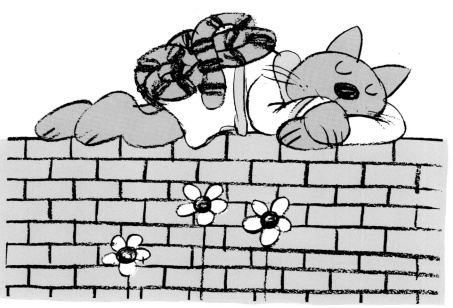

DRAW THE ROUGH OUTLINE OF YOUR
BEST IDEA IN PENCIL

COVER THE PENCIL LINES WITH INK
FROM EITHER A PAINT BRUSH OR PEN

TOUCH UP YOUR BLACK LINE IF IT HAS
BEEN BROKEN BY AREAS OF PAINT

HAVE A CUP
OF COFFEE

THE PICTURE ITSELF IS NOW FINISHED
MAKING A MASK IS THE FINAL STAGE

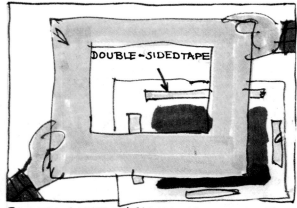

DOUBLE-SIDED TAPE

POSITION THE MASK USING DOUBLE
SIDED TAPE TO HOLD IT IN POSITION

PROTECTIVE
PAPER

COVER THE MASK AND PICTURE WITH
A LAYER OF PROTECTIVE PAPER

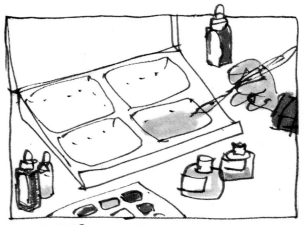

MIX WATER COLORS OR INKS AND

DON'T WORRY ABOUT THE EDGE OF THE PAINTING AS YOU CAN MAKE A MASK

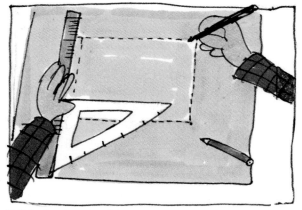

DRAW UP THE AREA OF THE MASK USING A SET SQUARE AND STEEL RULE

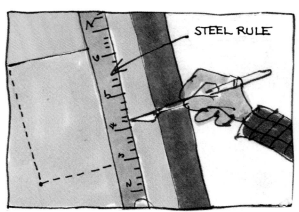

STEEL RULE

USE A SCALPEL WITH A FRESH BLADE TO CUT OUT THE MASK

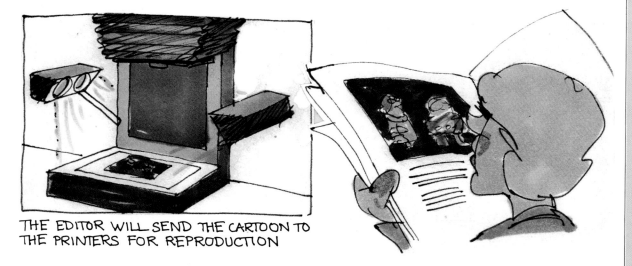

THE EDITOR WILL SEND THE CARTOON TO THE PRINTERS FOR REPRODUCTION

blacker and better defined. Reducing your cartoon usually improves its appearance, removing any imperfections in the line.

Small details, however, can almost disappear when a cartoon is reduced substantially. So keep everything simple. Parallel hatching will become solid if too close together as will a stippled area. Remember too that lettering will need to be large and clear. Finally, you will need to space out your figures and compositional elements with reduction in mind.

The enlargement of a cartoon has the opposite effect to reduction: the line becomes less dense and sharp and any imperfections are magnified. Unless it is unavoidable, enlargement of your work should not be encouraged.

Printing process

It has been mentioned that your style must depend to a certain extent on the printing process used to print your cartoon. Gravure is used for long-run color reproduction where color definition and detail are important. Letterpress is used for newspaper printing and the standard depends to a great extent on paper.

With apologies to their owners here are some famous signatures. Take trouble when choosing or designing your signature, so that you remain the one and only. Make sure you sign all your work clearly. It is one of the best forms of publicity.

When you have finally had enough rejection slips to paper a room, you will have completed your apprenticeship and you can consider yourself a professional cartoonist.

Lithography is the most common printing process but the results vary enormously. Your best bet is to look at the publication you are aiming for.

It is important to be aware of these different characteristics so that you can decide how to present your cartoon. Basically, unless you have been briefed to do a cartoon for a four-color publication, you will do better to keep your cartoons clear and simple without much minute detail.

Marking up

If you are presenting work for printing, it is sometimes useful to be able to pass on instructions to the printer. These instructions should be written in the margin of the cartoon and should be short and unambiguous.

For example, should there be any doubt about which way up the cartoon is to be printed (if one of your figures is standing on his head, for example), then write 'top' at the top and 'bottom' at the bottom. If you are involved in separation work you will need to place crosses – registration marks – at the top and bottom of the cartoon so that the overlays can be correctly aligned.

It is worth, however, consulting the editor or printer if you are producing a series of drawings to find out if there are any particular house rules.

Creating a system

You will find you soon create a system with your submissions. It is useful to number your cartoons, keeping track of them in a book or index. Mark down (a) who you submit a cartoon to (you do not want to send it twice), (b) if it is accepted, (c) when you were paid, or (d) when it was returned and (e) who you sent it on to.

If it is a topical cartoon or somehow you are not in tune with the editors (or *vice versa*) then file your returned cartoon in a 'dead' file. This will give you something to delve into if asked to produce something in a hurry or on a particular subject.

Signatures

Finally a cartoonist must have a name and a signature. They both require some thought. Most cartoonists take their own names or a shortened version. But it is worth doing some research in the local library to check that your chosen name does not belong already to a well-known cartoonist. I took my christian name as my signature but have since found two other cartoonists named Ross. Fortunately, I made a point of designing my signature so it has not mattered. Some cartoonists draw under various *noms de plume*.

You can have fun designing your signature. The collection on this page of some well-known signatures will give you some ideas – of what to avoid if nothing else.

Artistic styles

(With more apologies to Sempé, Steinberg, Larry, McMurtry, André François, Calman, Michael Williams, Heath, Scully and Jak.)

A high proportion of cartoonists admit to having started off by imitating their graphic heroes. They did not, of course, continue slavishly to reproduce cartoons – no editor would accept such plagiarism. But, by mimicking the experts, these cartoonists learnt about drawing and enriched their own eventual style.

This chapter aims to lead the aspiring cartoonist through the range of artistic styles currently fashionable. The object of the journey is to help inspire ideas and to give encouragement. Some may use it advantageously to more iconoclastic ends – to weigh up the opposition and possibly shoot down in flames.

What is certain is that the ethos of cartooning can be absorbed visually. This review of styles is intended to open your eyes, and to encourage you to immerse yourself in as much graphic humor as you can lay your hands on, from libraries, friends and – surreptitiously – at news-stands. It may sound like an awesome task – even if it is, there could hardly be one that is more enjoyable.

Simple black line

Cartoons for newspapers and non-glossy magazines, as we have discussed, call for a clear, simple outline. Apart from the practical consideration of the printing process, however, this economy of line also enables the point of the cartoon to be made abundantly clear and not shrouded in detail.

This line, refined to its bare essentials, becomes the basis of a cartoonist's style and, as will become clear, no two cartoonists have the same style. A close look at the cartoons in this book will show you how the line itself is autographic.

Uniform width

Some cartoonists create a line of uniform width – without any fluctuations. This is usually achieved with a stylo-tipped reservoir pen, a fiber-tip pen or even a ball-point.

Even though the line is unvaried in width, this does not mean it is lacking in character. In the United States, Saul Steinburg's graphic acrobatics employ a

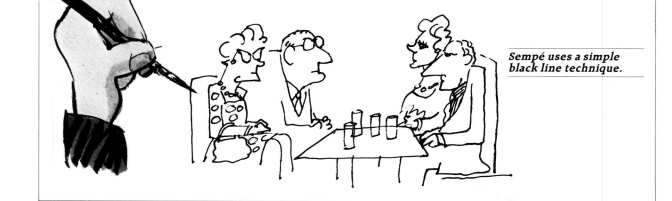

Sempé uses a simple black line technique.

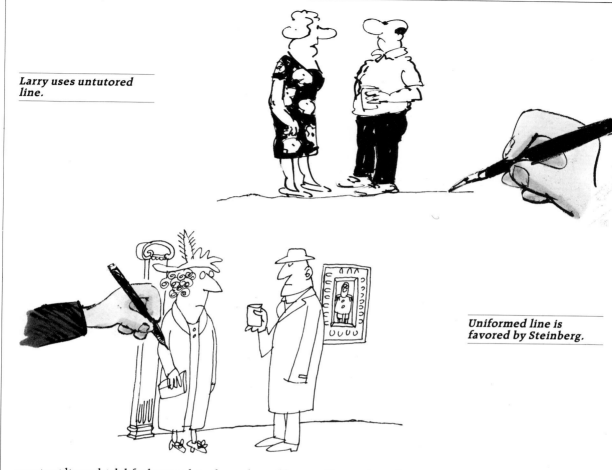

Larry uses untutored line.

Uniformed line is favored by Steinberg.

constant line which lifts his work to the realms of fine art. His work can be seen in *The New Yorker* magazine and is worth searching for, but he discourages the reproduction of his work in publications beyond his control.

The West German cartoonist Hans Georg Rauch, too, employs a clean line to mobilize his armies and crowds. His intimate knowledge of various printing methods has put his work, like Steinburg's, in the fine art category.

Untutored line

There are fashions in cartooning just like everything else. A noticeable trend over the last decade has been towards a less tutored line. The aim has been to try and retain the spirit of the creation which is usually lost in the inking over process. Many cartoonists therefore work in ink omitting the sketching stage. This tends to produce a less finished look. On the other hand, you will often find a cartoonist slaving away at a sketch, refining the idea to perfection, and then inking it in to make it *look* as though it has been hastily penned.

However the line is achieved, there has been a loosening up of style. The work of Jean-Jacques Sempé, which has evolved from a stiff line to a more fluid one over the last decade, illustrates this. The inventor of the Peanuts gang, Charles Schultz, has also seen the same development take place in his refined line. This casual informality can also be seen in the drawings of British cartoonists Frank Dickens, with his 'Bristow' strip, and Larry (Terence Parkes), in his hilarious glimpses of everyday life.

*Stan McMurtry favors
fluctuating line.*

The so-called untutored look is sometimes taken to extremes with great effect. The American Edward Koren seems to unravel his line like knitting, creating a dancing, vital surface for his cartoons. But when you look at his work, your eyes focus on the shaggy Yeti-like beasts which populate his real world, and his highly individualistic style goes almost unnoticed.

Another less extreme exponent of the unraveled knitting brigade is that master of simplicity, Jean-Pierre Desclozeaux. His pen is very fine and economically employed, yet it almost vibrates causing a shaky broken line which makes his drawings captivating.

Fluctuating line

A fluctuating line is produced by a pen nib or brush which is controlled through pressure or angle ranging the width. This produces a more fluid line.

The British cartoonists Michael ffolkes and Quentin Blake deploy such a line in their finely wrought, elegant drawings of high quality. But more simple drawings can also use such a line. Osbert Lancaster, Marc (Mark Boxer) and Barry Fantoni all produce pocket cartoons in British national papers. For this particular outlet, they have to employ linear economics. Osbert Lancaster uses a fluid decorative line to compose the antics of Lord and Lady Littlehampton. Marc's middle-class intellectuals are drawn with a stiffer more varied outline, but nothing compared with Barry Fantoni's line which is wrought like bent wire.

Sculpted line

The untutored version of the fluctuating line is epitomized in the work of the Romanian born French cartoonist, André François. André François in tandem with his pen produces a line which is almost three-dimensional. It varies in width dramatically, sometimes bleeding into the paper when too much ink is applied. These wayward means of self-expression eked out by the pen are positively encouraged and produce an image which aptly reflects his idiosyncratic brand of humor.

Ronald Searle draws a variable line, not only as it proceeds but also to emphasize the position of his figures in the pictorial space. Hence objects in the foreground – or those of most significance – are drawn with a thick sensuous line. The line gets finer as it recedes into the background.

This section cannot be complete without reference to one of the greatest, most vicious cartoonists of our day, Ralph Steadman. The manner in which he signs himself gives a preview of the lack of respect that his style evokes. His signature is a combination of thick and thin lines, with upper and lower case letters mixed together. His cartoons are a combination of hard incisive ruled lines and explosive

André François aims for a more sculpted effect.

areas of confused yet vital texture. Everything is intended. No blot is unintentional. And the results are devastating.

Sketchy line

One more type of line needs acknowledgment – the sketchy line, created with a pencil, charcoal, wax pencil or dry brush. Such a line is transformed through reduction yet it requires linear simplification in its extreme.

One of Britain's best loved cartoonists Mel Calman, uses a smudgy line for his humorous vignettes. Robert Osborn in the United States spent years distilling his line down to the expressive extreme he employs to capture his political targets.

Tonal modulation

Tonal modulation can be achieved in a cartoon through linear hatching, tonal washes or through the use of mechanical tints. Some cartoonists stick to a particular technique while others vary according to their brief.

Linear tone

There are several cartoonists who have returned to the techniques of nineteenth-century caricaturists. The most impressive of these is American David Levine whose incisive fluid line and delicate cross-hatching is used to deadly effect. His cartoons are widely admired and mimicked for their graphic as well as intellectual qualities.

Calman strives for the sketchy.

In Britain his work is matched by that of Gerald Scarfe, who distorts and exaggerates his caricatures almost beyond recognition. Scarfe's outline is clear cut and his tonal areas are hatched with series of sometimes minute lines creating a depth of texture.

Michael Heath, a *Punch* cartoonist, employs linear hatching to much more informal, yet very effective ends. Series of hatching on his figures place them within the picture space, giving them a cardboard cutout flatness which suits his world of stereotypes.

This linear style reaches a glorious extreme with the work of Paul Flora whose confluence of cross-hatching sometimes achieves the texture of tonal soup. In that soup though there are arresting images which bear witness to his great skill.

Tonal washes and mechanical tints

The fluid line of Michael ffolkes and Quentin Blake is more often than not accompanied by a tonal wash to suggest form and to give a softness and delicacy achieved by few others. Charles Addams, on the other hand, in his cartoons for *The New Yorker*, uses washes of tone to create the perpetually dark spooky world of his Munster family.

For the gag market, *Punch* cartoonists, William Scully and David Langdon, show how a simple wash can be put to good effect.

For use with the cheaper forms of printings, mechanical tints are liberally employed by many of the gag cartoonists.

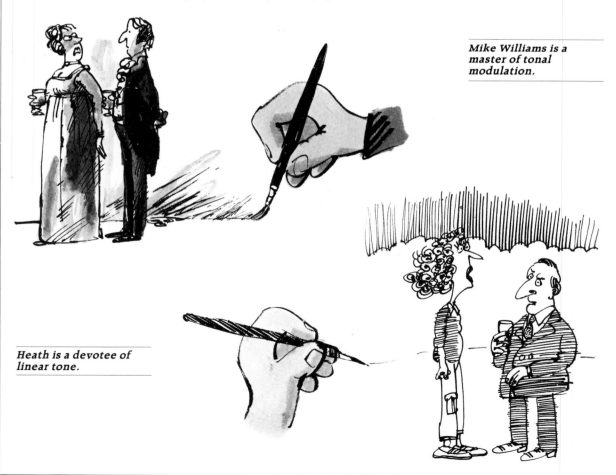

Mike Williams is a master of tonal modulation.

Heath is a devotee of linear tone.

Tonal washes, as used by Scully.

Detail

Some cartoonists, despite exhortations to reduce the clutter in their work, positively wallow in the glory of detail. That detail is not in any way irrelevant but is additional to the main point and allows the reader to ponder on the cartoon for more than a fleeting moment and appreciate these less important 'jokes'.

In Britain Carl Giles fills his tableaux depicting the Giles family with such minutiae. Jak (Raymond Jackson) and Mac (Stanley McMurtry) have a similar style.

Charles Addams delights us with the cobweb-infested peeling walls and rotting floors of the Munster family home. Ronald Searle entertains us with bursts of detail which form focal areas in his cartoons. Arnold Roth's detailed tableaux are definitely worth studying to obtain the full worth of his infectious humor.

Color

Finally let us look at some cartoonists who use color in their work. Most cartoonists use color at some time, but there are certain practitioners who are especially skilled in its manipulation.

Jean-Pierre Desclozeaux employs color often to make his jokes; if the cartoon was printed in black and white, the point would be lost. His use of color is supreme, making his cartoons amongst the most appreciated today.

Ralph Steadman, too, uses color with skill and flair splashing it and spraying it on his cartoon. The result is what Steven Heller terms a 'visual essay'.

Of the more painterly cartoonists, André François, Hans Georg Rauch and Tomi Ungerer like to express themselves in gouache or acrylic when these media are suitable.

Cartoon styles

YOU CAN TAKE a butterfly to pieces to see how it works but you then no longer have a butterfly. The same end-result applies when anyone systematically tries to dissect cartoon humor; a cartoon is a delicate construction like the butterfly, no matter how robustly drawn, and its spark is inevitably snuffed out when subjected to that kind of analysis. But cartoons do fall naturally into recognizable categories and it is these broader bands of definition which can be put under closer scrutiny without causing too much damage. These divisions are there not because they have to be; they largely exist because certain cartoon humorists have at one time or another struck out in a different direction from that followed by the broad mass of cartoonists. An individual quirkiness or peculiar intelligence has guided them toward these new areas and, once they have pioneered and marked out the trail, other cartoonists are not slow to follow.

Perhaps the richest source of raw material for the cartoonist is ordinary human behavior in day-to-day life. The jokes spring from situations that we all recognize.

Another branch of cartooning makes a social comment, using humor to illuminate some element of the social structure – usually of a critical and mordant nature. Zany and surreal humor can be fantastical, illogical and unfettered – one which perhaps appeals only to those readers with a similar humorous bent. Then there is topical comment – jokes about what is happening in the world as brought to us in our daily newspapers and radio bulletins. Visual punning is a form of humor which, by its nature, is essentially pictorial and possible only in cartoons or on film; black or gallows humor enters a more sensitive area where, some readers react to this kind of cartoon with indignation rather than amusement.

It must be stressed that these sections are largely artificial and do not necessarily include every shade of drawn risibility. In this house there are many rooms, and long may that be so.

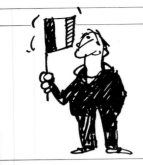

National and international styles

Cartoonists the world over often use their craft to point up the abuses they see inflicted on the quality of life around them. These drawings can be very telling and vivid indeed, like this one by Dallos, a Hungarian artist. His pictorial comment on the encroaching spread of cities could be applied universally.

O ne day in the mid-1970s a journalist on the Australian *Sydney Bulletin* decided to cast an eye over the quality of all major cartoonists then working for the British national press: he was not very impressed. In his view they were a pretty poor bunch and conspicuously inferior to the native Australian talent then available. This attack was slightly misdirected, however, because at that time the principal cartoonists employed by some British papers, the *Daily Mirror*, the *Sunday Telegraph*, the *Sun*, the *Guardian* and the *Daily Mail* were either Australians or New Zealanders. Apart from demonstrating that the antipodes seems to produce more cartoonists per acre than anywhere else in the world, their predominance in London, then, as now, also underlines the fact that cartoonists do move around and their work, like music, can effectively straddle most national boundaries.

Universal language

In subject matter and visual syntax, most cartoonists happily speak a universal language: the emphasis may vary slightly but they dig out their jokes from the same patch of ground: the war between the sexes, bureaucracy, money, awkward

Urbanization

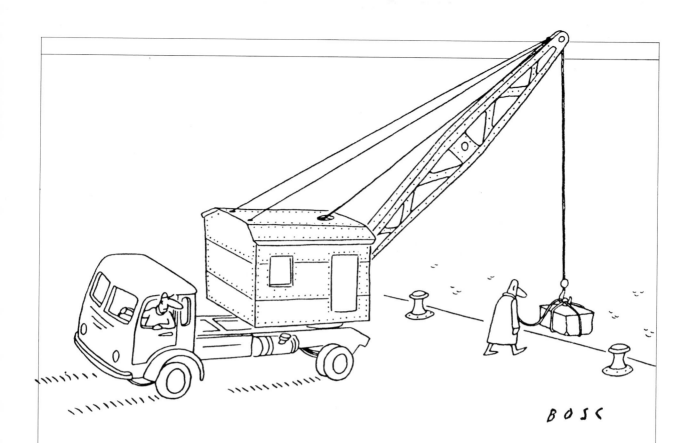

BOSC

teenagers, driving, doctors, drunks, animals, ecology, and so on. Look through the humor magazines from East to West and you will recognize that they cover very familiar territory and their treatment of it is similarly varied – run-of-the-mill, zany, off-beat, surreal.

There are areas of different emphasis, of course, areas that do reflect the shape of a national characteristic. Central European countries, for instance, tend to go in for earnest, symbolic drawings with a MESSAGE – a tank driving round a daffodil, or bedraggled doves. The drawings, which are generally arty or scratchy, ooze self-righteousness and are displayed in exhibitions and reproduced in expensive books. One cartoonist who stands well above these is Hans Georg Rauch, a West German. He is first and foremost an artist; his elegant pictorial metaphors jerk our view of the world into a new, strange alignment.

France

The French are more down to earth and scatological and, like the Japanese, prone to the sick humor of hangings and decapitations. But their cartoons can also be suffused with charm, as in the work of Raymond Peynet and Jean-Jacques Sempé. And it was the Romanian-Frenchman André Francois who influenced British humorous art so powerfully after World War II. In the 1950s his was a strange and different kind of humor, moreover his drawing style was not 'cartoony' at all but in some respects rather childlike. His work appeared principally in the British magazines *Lilliput* and *Punch* and even today you can see traces of his style lurking in the drawings of many different hands.

The French, too, are now challenging American supremacy in the international strip cartoon market; they have developed a more serious form which is thought to be more artistic and is read by millions of adults. 'Tintin' is a major industry and Asterix, the little Gaulish warrior, is a national hero. Drawn in a Disneyesque

The Frenchman Bosc draws in what might be called the 'bent wire' style. The people who appear in his cartoons are rudimentary. They never vary. And everything in the drawing is there solely to project the joke idea – a discipline the budding cartoonist could do well to bear in mind.

Rowland Emett not only caricatures people, he caricatures things as well. Starting from a real knowledge of what steam locomotives look like and how they operate, he uses an artist's perception to distort and exaggerate to an extraordinary degree – and yet we have little doubt that what he draws would still function as locomotives.

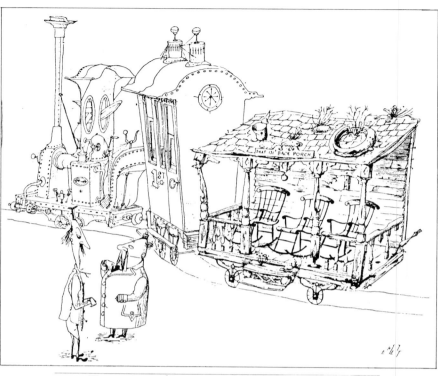

'Yes, we're making a special bid for the American tourist business this summer . . .'

'Don't shake my hand then.'

When the Russians draw political cartoons they are naturally never self-critical. Their targets are invariably the USA and West Germany. This cartoon is from the Soviet humor magazine *Krokodil*, but is apolitical.

style. 'Asterix' was originally conceived for children but it quickly gained an adult readership because of its oblique form of satire.

British humor

As for the United Kingdom, the bulk of its cartoons have no difficulty in crossing all frontiers but there are one of two areas which remain peculiarly British, or more precisely, English. Rowland Emett's 'Far Twittering and Oyster Creek Railway' could never be anything else but English; it chimes on the national regard for the quaint and the picturesque as well as the Englishman's baffling love of steam engines. Heath Robinson is another man pixilated by loony machines – his complicated mechanical inventions consisting of pulleys, pipes, bent nails and knotted string which help expedite useful activities such as grading coke or catching burglars. Robinson himself maintained that the popularity of this brand of humor relied not just on the fantastic machines and absurd situations, but also on the suspicion that the artist believed in them totally. His name is now lodged in the language as an adjective for any ramshackle contraption. Down at the other end of the market stands Donald McGill and his saucy seaside postcards bursting with roly-poly figures and heavy *double entendres*. The genre is coarse, ribald, and harmlessly funny. Is there anything like it anywhere else in the world?

But it would be wrong to think that Englishness in cartooning always leans towards the whimsical; the acerbic work of Ronald Searle and Gerald Scarfe, among others, provides the correction to that assumption.

American style

And now the Americans: first of all they must be saluted, and particularly the magazine, *The New Yorker*, for rescuing the cartoon from under the weighty

drapery of Victorian illustration – a congested creation with a verbose dialog caption. They developed a new shorthand form of drawing, essentially quick, direct and expressive with the accent on vitality and movement. The captions were pared down until occasionally they disappeared altogether leaving the picture to do all the work. These streamlined ideas demanded a streamlined response from the reader – any sluggards were left behind. Innovatons such as these quickly crossed the Atlantic to Europe; British cartoonists like Paul Crum, who in 1937 gave the world that classic hippo who kept thinking it was Tuesday, would never have produced such odd-ball ideas without the American influence. Today transatlantic trade in cartoon influence is less obvious as the brands of humor are almost indistinguishable. Certain individuals, however, attract attention and spawn new generations of cartoonists in their mold – the intellectual, Saul Steinberg, and the master of ghouls, Charles Addams, have a world-wide following.

Russia

Russian cartoonists on the whole, and not unexpectedly, draw in a rather old-fashioned 1920s style, if their humor magazine *Krokodil* is anything to go by. Nothing outlandish or experimental, only total competence – and rather engaging because of that. They, too, deal with drunkenness and shortages and the foibles of married life. If there is a drawing-board in the *Krokodil* office with an Australian behind it, we would not be too surprised.

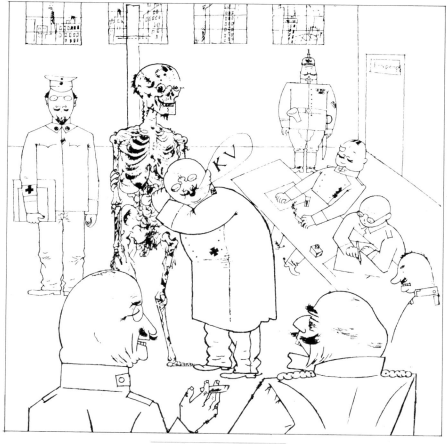

The faith leaders

George Grosz, the artist, produced his most brilliant and devastating satirical drawings in Berlin in the 1920s and yet they have the appearance of being very much of the 1980s. His response to the political and social scene was bitter and mordant – an attitude amply reflected by his economical style and sharp characterisation of human types. This example attacks the Army Medical Boards for their eagerness to return unfit soldiers to the battle zone. KV is an acronym meaning 'Fit for active duty.'

Social settings

One particular division of pictorial humor can be referred to as social comment, loosely meaning that here the cartoonist demonstrates a point of view. Such a cartoonist keeps a sharp eye on the passing show – the events, trends, fashions, and attitudes – then takes up his pen to make a comment on any happening that attracts him as worthy of notice. The jokes can be slight or devastating but they generally register strongly with the reader because they are larded with an element of ridicule.

Sacred cows

The reader, of course, has to be aware of all those events and trends that the cartoonist is shooting at and, if he feels the same way about them, then he reckons the cartoonist to be a very bright and funny fellow indeed. But, if his own sacred cows are subjected to a similar piece of rough treatment, then, human nature being what it is, he will decide that the cartoonist's efforts are really rather feeble. A cartoon about, say, factory farming will tend to be funny or not funny depending on your views on such treatment of animals. The factory farmer will certainly respond differently to such a cartoon than will a supporter of the animal rights movement.

Social comment cartoons, then, are double edged. They amuse, but they criticize. They illuminate an area of social activity, behavior or event with a quick

Most cartoons nowadays have quick, slick captions or no captions at all. However, certain jokes depend on having a long, drawn out caption, as this sophisticated example by the American cartoonist Henry Martin amply demonstrates. And his fluid drawing style tells us all we need to know.

'Mr Jepson said that while I was sending out for coffee he would like a hamburger. Mr Willis said that he thought he would like a hamburger, too, medium with no tomato. Ms Lester said that that sounded good and that she would like hamburger, too, rare with a side of French fries. Mr Anderson said that if everybody else was going to have something to eat he might as well have a meatball sandwich and a piece of apple pie. Mrs Colby said she'd like a slice of anchovy pizza and a bag of Fritlays . . .'

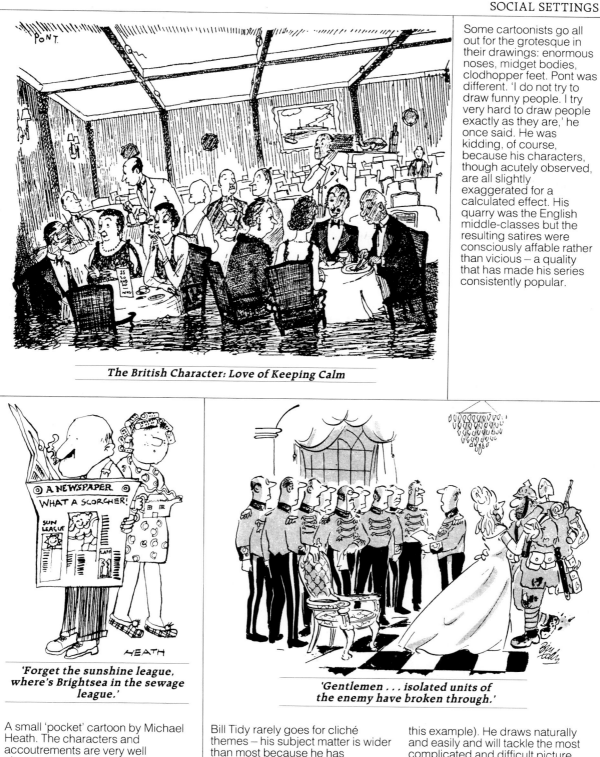

Some cartoonists go all out for the grotesque in their drawings: enormous noses, midget bodies, clodhopper feet. Pont was different. 'I do not try to draw funny people. I try very hard to draw people exactly as they are,' he once said. He was kidding, of course, because his characters, though acutely observed, are all slightly exaggerated for a calculated effect. His quarry was the English middle-classes but the resulting satires were consciously affable rather than vicious – a quality that has made his series consistently popular.

The British Character: Love of Keeping Calm

'Forget the sunshine league, where's Brightsea in the sewage league.'

A small 'pocket' cartoon by Michael Heath. The characters and accoutrements are very well observed.

'Gentlemen . . . isolated units of the enemy have broken through.'

Bill Tidy rarely goes for cliché themes – his subject matter is wider than most because he has accumulated an immense range of general knowledge (which includes authentic visual detail, as shown in this example). He draws naturally and easily and will tackle the most complicated and difficult picture with no qualms at all. But by giving a twist of logic to the situation, he can make it hilariously funny.

flash of humor – sometimes astringent, sometimes affable. On occasions they can ride alongside that other category, the political cartoon, but, whereas the political cartoon is usually declamatory and polemical (and a bit self-righteous, it has to be said), the social comment cartoonist is in there mainly for the laughs.

Illustrated social history

It would not be too far-fetched to claim that, week by week, year by year, cartoons in this category are steadily amassing a considerable record of social history, for they do illuminate and reflect what is going on out there in the real world. Any future assessment of life in England during the 1930s would be inadequate, for instance, without some reference to the cartoons by Pont. Similarly, if 100 years from now an earnest young post-graduate is buckling down to his treatise on mid-twentieth century urban life in the United States, then he would do well not to ignore the work of Jules Feiffer, Arnold Roth, or Henry Martin. More is known about the rumbustious side of eighteenth-century England because the drawings and engravings of William Hogarth and Thomas Rowlandson have so much to say.

'Daily topical'

There is a sub-division to the social comment cartoon and that is the 'daily topical'. It is true that these can cover much of the same ground outlined already, but they more usually hang on a precise topical event. To produce them requires a speedy reaction to these events so in almost all cases the practitioners of this particular kind of cartoon are people who are either staff or contract employees of a newspaper. Such cartoonists are given either a large and prominent place on the

Norman Thelwell's many cartoons about the pony-riding fraternity have made him famous, yet his best work has been concerned with important areas of social satire. He was quick to recognize trends as they began to appear and was equally quick with sharp cartoon comments. Factory-farming was a subject he returned to again and again – here is a good example. Note that only the people are cartoonified, the rest of the picture is very naturalistic.

'You can tell he's in agriculture. Typical farmers' pallor.'

'For Heaven's sake, why don't you go outdoors and trace something?'

Top left: Comical elephants abound in cartoons, greetings cards and humorous illustrations: The lumbering pachyderm is a universal cartoon favorite. Hoffnung, in this example, verges on the surreal.
Top right: This early drawing by André

François makes the audience search for the clues. Once they have spotted that single bead on the abacus they are required to make the correct deduction. Many cartoons have this riddle element – with the audience expected to do their part. The François style of drawing has been

a major influence on cartooning since the 1950s.
Above: A clever visual pun from the Dutch cartoonist Wessum: Once again the reader is expected to make the connection. A simple, clear drawing made more interesting by the use of texture.

Above right: A typical James Thurber creation. The drawing style here is basic, even awkward. But it is emphatically confident – that is its attraction. Married to Thurber's sophisticated ideas his drawings are very potent, and much copied.

Michael ffolkes's drawings are always elegant and aesthetically pleasing. He is an *artist*. He often goes to history and mythology for his subjects. His fellow cartoonists agree that he draws the best nudes in the business. An American admirer of his work once wrote to him: 'Mr. ffolkes, may I tell you that your drawing seems to be full of gin and buttercups.' That pleased ffolkes mightily.

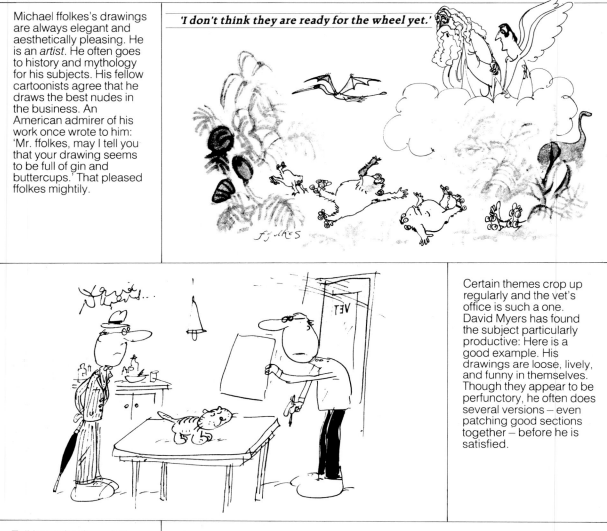

'I don't think they are ready for the wheel yet.'

Certain themes crop up regularly and the vet's office is such a one. David Myers has found the subject particularly productive: Here is a good example. His drawings are loose, lively, and funny in themselves. Though they appear to be perfunctory, he often does several versions – even patching good sections together – before he is satisfied.

Talking animals – what would cartoonists do without them? Just about every animal you can think of has featured in a funny drawing at one time or another – even weevils and microbes. The chameleons were drawn by Kenneth Mahood (one of the few cartoonists whose work has appeared regularly in *The New Yorker* and *Punch*) – a witty idea that functions immaculately. The drawing style is slightly stylized and decorative.

'Do you ever get tired of traveling incognito?'

114

inside pages, or a single-column 'pocket cartoon' position often on the front page. Their job is to respond not to general trends but to specific news stories, which means they need to comb through the news for items they can turn to their advantage. They then have to think up some ideas, get one passed by the editor, and then produce the finished drawing to a fixed deadline within the space of a few hours. The pocket cartoonists are at an advantage here because more often than not they rely on a drawing of two people talking to each other. If the news item involved is a rather minor one the reader will need to be reminded of it and the standard way round this problem is to include a drawn newspaper or bill-board, complete with headline, within the cartoon.

Women cartoonists

What about women cartoonists? Compared with men cartoonists there are fewer of them, but Harpur and Posy Simmonds in Britain, joined by the French, Bretecher, who are in the business, are social comment cartoonists of a deadly and subtle quality and in the top divisions of the trade.

Cartoonists sometimes think up ideas which depend on a sequence of pictures; these frames indicate the passage of time and tell a little anecdote. In this example Smilbey keeps the number of pictures down to three but other ideas might require many more.

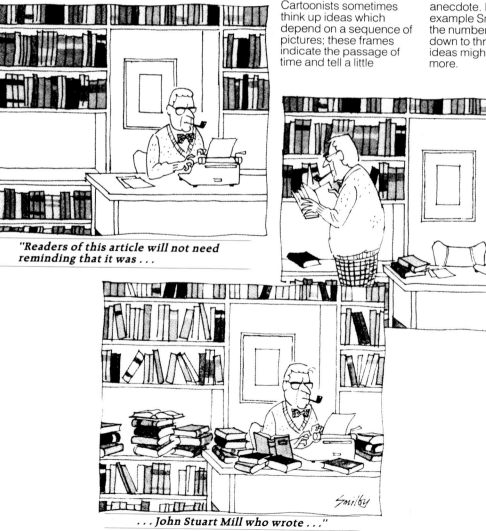

"Readers of this article will not need reminding that it was . . .

. . . John Stuart Mill who wrote . . ."

Politics and satire

A tight rope, a game of chess, an avalanche, a patient on the operating table – unlikely as it may seem all these disparate items have something in common: they are the visual metaphors you come across time and time again in political cartoons. You could also add ships heading for rocks, chasms, see-saws, runaway trains – the list is very long. And that is not all. In Britain characters from the works of Shakespeare and scenes from Alice in Wonderland were – and occasionally still are – trotted out regularly by the political cartoonist in his despairing search for an appropriate pictorial image which will fit the topical comment he wishes to make. And let us not forget the bears, eagles and lions that are included to represent Russia, the USA, and Britain, with a John Bull and Uncle Sam coming up in reserve. So it would not be unreasonable to claim that the mechanics of political cartooning are largely cliché-ridden – well-tried ingredients stirred into a standard mix – and if the end result seems to be fresh it is because this familiar imagery has been applied to a new and topical political situation. The cartoonist can also fall back on another ploy – he can link his political comment to *another* topical event. For example, if two countries are in dispute at the same time as the Wimbledon tennis tournament is taking place in London, the cartoonist can then depict the two heads of state competing at tennis – and possibly arguing with the umpire (who might be depicted as the UN).

Criticism

Using these clichés means that the reader is never overburdened with a strange new set of symbols and the critical point of the cartoon is readily understood. For all political cartoons *are* critical; they attack, that is their nature. They never

The first time the word 'cartoon' was used in connection with a printed picture in a humor magazine was with this drawing by John Leech. Previous to that the word applied solely to a preliminary drawing for a painting or tapestry. Leech's drawing (which bore the legend, *The Poor ask for Bread and the Philanthropy of the State accords – an Exhibition*) was a parody of an exhibition of cartoon designs for some frescoes intended for the Houses of Parliament. It appeared in *Punch* in 1843 at the time of the exhibition and was the first in a series of five. Subsequently *Punch* referred to all political drawings as cartoons.

CARTOON, Nº 1.

Substance and shadow

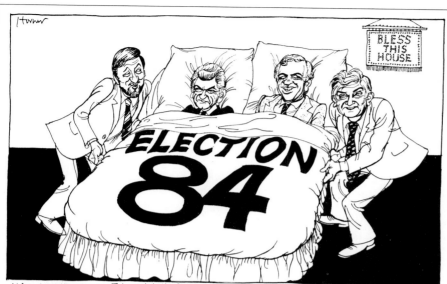

LYING TOGETHER : This week in the Senate, Government and Opposition voted together to remove a ban on untrue, misleading and deceptive political advertising.

Australia seems to produce more political cartoonists per head of population than any other country – probably a reflection of the ribald and iconoclastic nature of the average Australian. This cartoon by Horner, published in *The Age*, employs a visual pun to stress the popular view that politicians, of whatever party, all not always completely truthful. The politicians here depicted are Gareth Evans and Bob Hawke of the government, and Andrew Peacock and Peter Durack of the opposition.

This cartoon by Trog appeared in the London *Observer* when the South African President Botha was on a visit to London which happened to coincide with a Test cricket series between England and the West Indies. Trog pounced on this chance overlap to make an uncomplicated anti-apartheid point. This artist's drawings are always carefully and cleanly designed and he distributes the solid blacks, textures and open white spaces in a masterly fashion. Because it was Mr. Botha's first visit to the UK, Trog felt it safer to include his name.

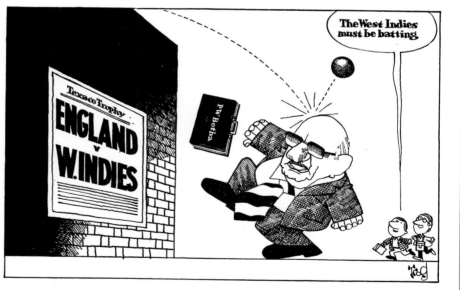

qualify, or say 'on the other hand', or pull their punches. They have to be direct, simple and essentially pictorial; those cartoons which rely on explanatory labels scattered all over the drawing have already admitted their own shortcomings – the best ones employ a vivid and powerful symbol and leave it at that.

These, then, are the cartoonists who castigate and demolish; these are the serious brigade. But there are other more genial political cartoonists, the ones who deflate and criticize through mockery and humor, and it can be argued that their work is just as effective because of that. Artists in either group cannot get very far, though, without possessing some fluency in the field of caricature, because the personalities of the political world are their main raw material.

Undoubtedly the big topical cartoons are a major and popular feature in most newspapers; they amuse, they infuriate, they reinforce a reader's prejudice. They also liven up those large grey areas of type. And the cartoonists themselves are

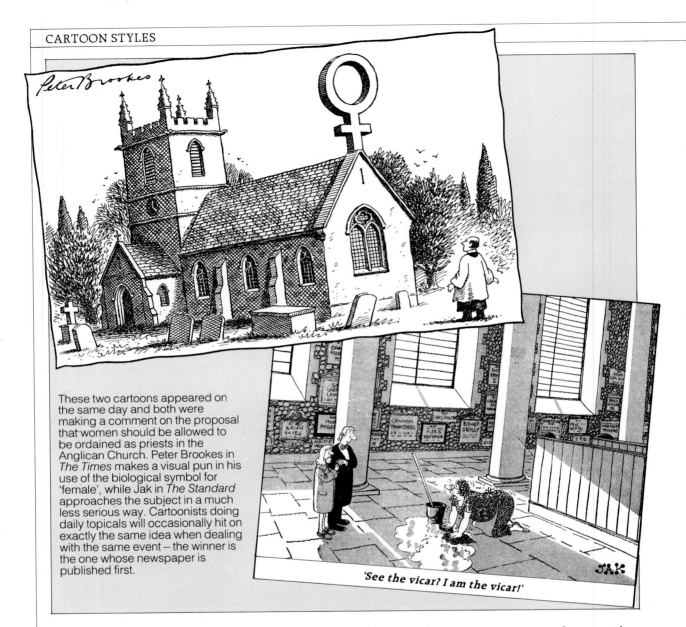

These two cartoons appeared on the same day and both were making a comment on the proposal that women should be allowed to be ordained as priests in the Anglican Church. Peter Brookes in *The Times* makes a visual pun in his use of the biological symbol for 'female', while Jak in *The Standard* approaches the subject in a much less serious way. Cartoonists doing daily topicals will occasionally hit on exactly the same idea when dealing with the same event – the winner is the one whose newspaper is published first.

'See the vicar? I am the vicar!'

recognized by their newspaper bosses as being important star performers – they have generous contracts and are handsomely paid. But they have to produce the goods. Some of the more prestigious and starry performers can lay down their own terms regarding the editing of their material, though such a prima donna is rather rare.

The cartoonist's influence

Can political cartoons topple a government, change a policy, or set off a revolution? Hardly. But it is true that they can niggle and that their effectiveness can on certain occasions cause minor explosions along the corridors of power. It is said that during World War II the work of British cartoonist David Low infuriated Hitler so much, it earned Low a place on the Nazi extermination list. A cartoon by Michael Cummings in 1959 annoyed the French Government to the point where they sent an official protest to the British Foreign Office. Such influence is rare but

there is no doubt that in Britain the tradition of blowing a raspberry at those in power is alive and well; the shades of that bitter and scurrilous early nineteenth-century graphic satirist James Gillray live on. (It should be noted, however, that Gillray was quite happy to engrave ideas given to him by patrons; he could also switch sides when it suited him to do so.)

This tradition of attack and comment through graphic lampoonery flourishes healthily in the United States and those other countries where this kind of freedom of expression is encouraged (or at least tolerated). In those places where there is any form of press censorship the activities of the political satirist are either non-existent or restricted to very carefully defined areas. Should you leaf through a dozen issues of *Krokodil*, the Soviet humor magazine, for instance, you will find cartoons about inept bureaucracy, or the social consequences of drunkenness. There will be regular attacks against American 'warmongering' and the evils of capitalism. What you will not find there are any critical cartoons aimed at Soviet leaders, the Communist Party or Russian foreign policy. These same restrictions apply in the Hungarian magazine *Ludas Matyi*, although it often republishes British political cartoons – but only those which attack the British Government.

So what makes a good political cartoonist? He should be a reasonably competent caricaturist and draftsman but most of all he should have a point of view. The most effective cartoonists are those who are natural cynics and whose view of the political scene is an essentially wary one. Osbert Lancaster, whose cartooning talents cover numerous categories, once wrote: 'The cartoonist must remain fundamentally bloody-minded, hold no cows sacred, and be capable of thoughts in the worst possible taste.'

Ronald Reagan's first inauguration as president as imagined by John Jensen. The artist picks up the president's film acting career as a method of posing a question to which only posterity will have the answer. A well organized design. confidently drawn.

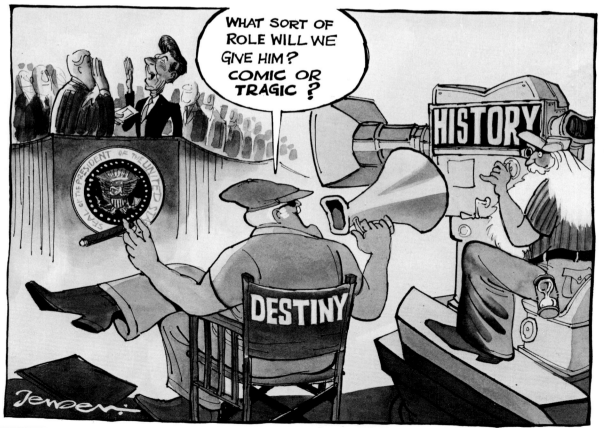

Spitting image

During World War II everyone was able to draw Adolf Hitler. A diagonal scribble for his hair and a smudge of moustache underneath and that was enough. No eyes, nose, or anything else – just the hair and the moustache. Child's play, it would seem, but caricature does not always come so easily.

The caricaturist's job can be defined simply. What he does is seek out physical characteristics and personal oddities which make his subject different from other people and then exaggerate them in his drawing. Part of the exercise is to catch the characteristic expression, stance and movement – and, some would say, do this in the most direct and economical way. Concentrate on the essentials and forget about the rest. Fortunately every caricaturist does not feel bound to produce just a simple pictogram, like that Hitler representation; what we have, happily, is a conspicuous variety of drawing styles which nonetheless do not waver from the principle of selected exaggeration, no matter how complicated or 'worked up' they are as drawings. A successful caricature it could be claimed, rather paradoxically, is more like the subject than the subject himself.

Ancient art of lampooning

Now, we would be slightly off-beam if we went along with the cheery notion that these drawings were always an amiable demonstration of a certain skill. Many are

Attacking influential people through caricature has been with us for a very long time. **Right:** An early sixteenth century example depicts Martin Luther as an instrument of the devil. **Left:** The caricature of King Louis-Philippe led to a court action which the artist won by demonstrating, through a series of sketches, that the King did really resemble a pear.

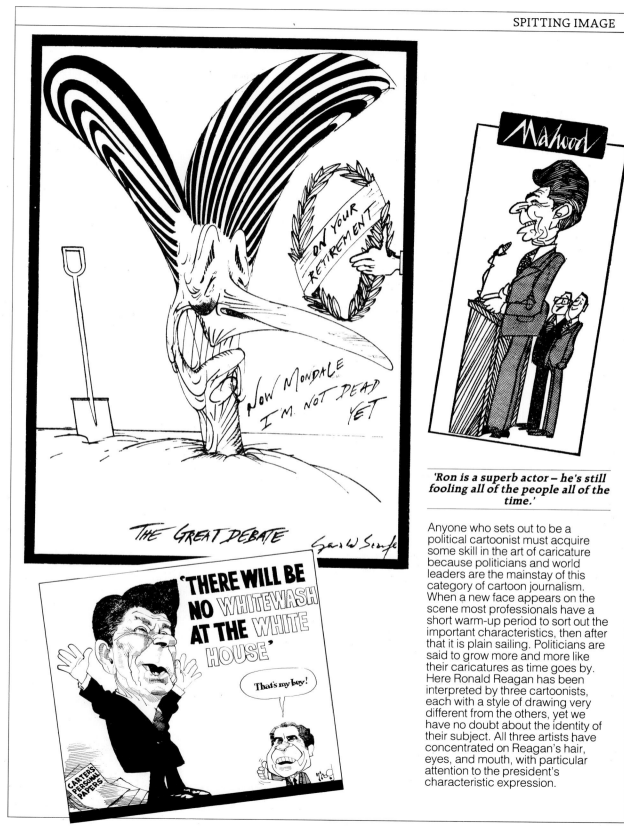

NOW MONDALE I'M NOT DEAD YET

ON YOUR RETIREMENT

THE GREAT DEBATE

Gerald Scarfe

'Ron is a superb actor – he's still fooling all of the people all of the time.'

'THERE WILL BE NO WHITEWASH AT THE WHITE HOUSE'

That's my boy!

CARTERS PERSONAL PAPERS

Anyone who sets out to be a political cartoonist must acquire some skill in the art of caricature because politicians and world leaders are the mainstay of this category of cartoon journalism. When a new face appears on the scene most professionals have a short warm-up period to sort out the important characteristics, then after that it is plain sailing. Politicians are said to grow more and more like their caricatures as time goes by. Here Ronald Reagan has been interpreted by three cartoonists, each with a style of drawing very different from the others, yet we have no doubt about the identity of their subject. All three artists have concentrated on Reagan's hair, eyes, and mouth, with particular attention to the president's characteristic expression.

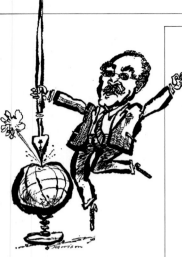

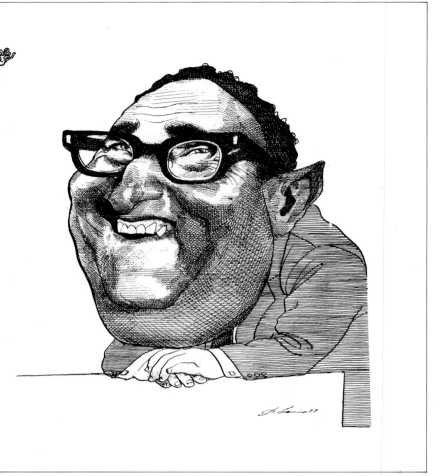

Above: The Hewison caricature was drawn to accompany a newspaper article about the globe-trotting humorist SJ Perelman. Comparing cartoons with his regular theater review caricature (see page 67), he has changed his style and used a different pen technique. It is more decorative and more appropriate to this particular assignment.
Above right: The fine caricature of Henry Kissinger is unmistakably from the hand of David Levine, whose drawings always have a strong three-dimensional quality derived from his careful cross-hatching method. This technique has been borrowed from nineteenth century illustrators, such as John Tenniel. Anyone attempting it should have a solid grounding in draftsmanship.

just that but most have a more malignant purpose – that of lampoonery and ridicule. The pen in this case is undoubtedly dipped in acid and the artist – often through the introduction of another element or symbol – is bent on destruction. A fine example of this is an early sixteenth-century caricature of the German religious reformer, Martin Luther, in which he is depicted as a set of bag-pipes being played by the Devil. In the mid-nineteenth century a caricaturist transformed King Louis-Philippe into a pear – *poire* being French slang for dullard. And in England George Cruikshank's scurrilous vendetta against the Prince Regent prompted the Royal Household in 1820 to approach him with a bribe: £100 if he would 'pledge not to caricature His Majesty in any immoral situation'. The bribe was refused. Nowadays this 'attacking' tradition is found most often in political cartoons, so that when President Reagan is depicted as a geriatric Superman, or Margaret Thatcher, in armour, as the Iron Lady, the caricatures of these people are merely one element in the structure of the attack. The artist here is a political cartoonist first, caricaturist second.

Catching a likeness
So how do these artists go about their task? By direct observation of their subjects, by watching them on television or film, by using photographic reference, and (whisper it softly) by retreading caricatures already done by others.

Right: The Swedish cartoonist Ewert Karlsson revels in what the pen nib can do and exploits the technique to the very limit. As this caricature of Colonel Gaddafi shows, Karlsson's spiky pen line jabs and sputters on the drawings, the pressure on the nib giving great variety to the character and thickness of these lines. And like Levine, his drawings, though distorted according to the principles of caricature, are all based on sound academic knowledge. Karlsson has produced several books of drawings, including one which pictured 63 portraits of world leaders.

For 12 years Bob Sherriffs drew the weekly film caricature for *Punch*. **Above:** John Wayne in *The Sands of Iwo Jima* drawn in the characteristic Sherriffs brush style. He once said of his technique: 'I decided that the brush was better than the pen, for all manner of drawing, and confirmed my previous conviction that figures and faces were patterns to be studied and memorized . . . I regarded caricatures as designs, and the expressions on faces merely as changes in a basic pattern.'

Those caricaturists who use photographs have a more difficult job because the photograph is already one step away from the original and the information therein is necessarily limited. But Trog and David Levine who work that way have shown they can surmount those obstacles. They both employ a 'worked up' style, Levine's being effectively pastiche Victorian.

The degree of exaggeration employed by each individual caricaturist varies enormously. R. S. Sherriffs, for instance, is restrained and friendly. At the other end of the scale is Gerald Scarfe who distorts violently with a deadly intent. Some readers hate his work; nevertheless, Scarfe is quite brilliant.

Back-handed compliment

It is often thought that caricatures, by their very nature, are cruel and offensive to their victims. It would seem, however, that 99 per cent of these victims are not so offended but, on the contrary, are flattered and delighted. This must be because they are usually people prominent in the public eye – politicians and those in show business – and the small spot-light of a caricature confirms and maintains their position. Any professional political cartoonist knows by long experience that the day he includes a caricature of a politician, however offensive, that person will be on the telephone to him within hours of its publication with a request to buy the original drawing.

Box by box

Strip cartoons in one form or another have been around for quite some time. Taking their cue no doubt from the ancient Chinese observation that a picture is worth a thousand words, people a long way back decided that a series of little drawings laid out in horizontal rows could tell a story both quickly and painlessly and, what is more, entertainingly. And this form of story-telling was attractive, not only to the unschooled and illiterate, but also to those whose education had been pitched to a more sophisticated and elevated level. Picture narrative was acceptable when it recorded popular myths or historical events: the voyage of Odysseus travels round the belly of a Corinthian vase of the mid-seventh century BC; the triumphant exploits of Emperor Trajan and his armies in the second century were depicted in relief sculpture spiraling up a giant marble column; the Norman invasion of Britain in the eleventh century is commemorated in an immensely long strip of embroidered pictures now known as the Bayeux Tapestry.

In all three there is drama and lively action – the standard ingredients of much of the published strip cartoons of today. And yet there has always been a tendency – probably stronger in Britain than elsewhere – for the strip cartoon form as published in newspapers to be derided and dismissed as low-brow kids' stuff. This attitude has weakened more recently but it is still around, and possibly

Both these strips are syndicated world wide and they are good examples of the self-contained daily episode with the pay-off in the final frame. The themes are essentially domestic, and the protagonists in both have been created as attractive villains. Everything is depicted flat-on, with very little, if any, perspective.

derives from the fact that in the United Kingdom cartoon strips have traditionally been collected into separate, custom-built publications aimed directly at children – comics. In America the situation was rather different; the strips appeared piecemeal in newspapers and were meant for the adult reader. The nearest American equivalent to the British comic is the comic book, a publication quite separate from newspapers and again, aimed at adults. At first these contained reprints of well-known newspaper strips, only later developing into new, lengthy features specially created for the book.

Superman and friends

It was at this point that 'Superman' entered the scene, the first of those mythical comic book heroes equipped with amazing magical powers. Created by Jerry Siegel and Joe Shuster, the strip quickly established itself and gained an immense popularity. Its formula – a character composed of two identities (Clark Kent, the bespectacled weakling who, when duty calls, hurries to a telephone box and emerges as Superman, the flying man of action) – was a brilliant notion and one which fathered many hybrids, like 'Spiderman' and 'Captain America', and currently 'Firestorm, the Nuclear Man', which goes one further by encapsulating not two characters but three – the third being a scientist/conscience figure constantly chipping in with advice.

These are part of the Zap! Kerpow! genre, full of invention and drawn with great skill – put together usually by a team of six, by-lined as Writer, Penciler, Inker, Letterer, Colorist, and Editor. And into these pages of hokum the writers sometimes contrive to insert little private jokes: when a bazooka-toting skysled is referred to as 'Rosebud', probably only a few of the readers would catch the 'Citizen Kane' connection. The mainspring of 'Superman' and its followers is strong sci-fi fantasy and recurring conflict. On the other hand the mass of daily newspaper strips concern themselves with ordinary life and the normal relationships between people; with these strips, established cartoon characters act

Top: Modesty Blaise is a serial strip where each story takes several weeks to run its course. The style is sound, naturalistic drawing and the techniques are cinematic in their use of close-ups, long-shots, and dramatic angles – this gives the strip visual variety and helps to create excitement.
Above: *Fred Basset* was on to a winner at the very start: a dog who could let us, the readers, know what he was thinking while the humans within the strip were not so privileged. This is pure domestic/recognition humor and it is deservedly very popular. Predictably, the artist Alex Graham shares his house with a basset hound.

125

For a French cartoon strip *Asterix* is very un-European in style; it has obviously been modeled on the American animated film cartoon with many Disneyesque mannerisms. But it is slick and completely professional, with Asterix, the heroic little Gaul, winning hands down against all foreigners. In that regard it is very French. This single frame demonstrates all the standard cartoon methods of depicting expressions, movement and violent action.

out each day a heightened and jokey form of domesticity. We can all plug in to these characters and situations because they are not very far away from the familiar territory of our own everyday lives.

That is why so many strips are syndicated world-wide and read by millions. Snoopy and the 'Peanuts' gang crop up in newspapers everywhere; the daily doings of that very British 'Fred Basset' and the Geordie layabout 'Andy Capp' seem to have no trouble in crossing all language barriers. Britain might produce only a mere fraction of the number of daily strips that appear in American newspapers but it still turns out a remarkable number of juvenile comics, even if the market for them is substantially smaller than it was 40 years ago. *Chips, Comic Cuts, Funny Wonder, Film Fun,* and *Knock Out* are some of the great titles of the past now dead and gone. But those two swashbuckling and gleefully anarchic publications, *Beano* and *Dandy,* are still happily around.

8. " Glad you like it, old sport !" wuffled Willie. " Now, let's sit down and polish it off before the luxury-tax collector calls." "I'm with you, boy !" burbled Tim. "As a furniture polisher I'm the absolute expert !" But just as our pair were beginning to feel at home in their new training-quarters, they were rudely disturbed.

These four samples have each been taken from longer sequences to show that the strip formula can accommodate a wide variety of drawing styles and fulfill many different purposes. **Left:** *Weary Willie and Tired Tim* has the characteristic picture style of those children's comics published in Britain between the Wars, full of schoolboy puns and skirmishes with the swells. **Below:** *Bustards* is a very topical Australian political strip, where leading politicians are given the full satirical treatment. The final two strips are by women, the English 'Posy' and the French Bretecher. Both artists do not concern themselves with the telling of jokes. Their purpose is social satire. **Below middle:** Posy is particularly incisive at the expense of the trendy British educated classes. **Bottom:** Bretecher is subtle and sympathetic when she regards the Sisterhood of women. Both draw fluently and well.

Parental dilemma

Criticism made against the comic strip has usually come from serious-minded parents uneasy about what they reckon is the essential triviality and simplicity of the form. They believe that kids hooked on such things are being led away from better literature and more mind-expanding activities. A weightier criticism was leveled at the so-called horror comics, conceived in the 1950s, a grisly collection of nastiness put out by the shadier sections of American publishing houses, and which led Britain to bring about action for import restrictions. There was criticism of these comic nasties in the United States too, the pressure of which persuaded the comic book publishers to form an association with a self-imposed code of standards. Even so, there is some justification for the claim that those people who, for one reason or another, were prevented from reading comics during their childhood, have surely missed out on a big slice of pop culture and the harmless enjoyment derived from it.

So it can be said that there is little evidence that the extremely wide range of funny, zany, romantic, irreverent, incredible, and violent adventure strips read by millions of juveniles over many years have had any corrupting influence on them. There is usually a basic line of morality running through those 'young love' picture stories aimed at the adolescent girl. Children naturally prefer the humor of slapstick and iconoclasm; their heroes are generally rebels, the ones who get into trouble, and the most favorite characters of British comics, like 'Weary Willie' and 'Tired Tim', 'Korky the Cat', 'Desperate Dan' and 'Lord Snooty', are usually robust and subversive. None of us, however, who grew up reading our share of comics has really been coerced by them into criminal or anti-social behavior, now have we?

Categories

The regular newspaper strips can be broken down into rough and ready categories. First, the humorous strip which tells us a joke within three or four frames, such as 'Andy Capp' or 'Peanuts', which normally feature the same set of characters. Then there is the strip which is part of a continuing serial story in daily

Four artists – Penciler, Inker, Letterer, Colorist – were involved in producing these frames from a recent *Firestorm, the Nuclear Man* strip, a typical example of much of the material found in American comic books. It is science fiction/fantasy with all-powerful heroes and packed with action.

or weekly episodes. These can be light and humorous or dramatic and serious. Occasionally the creators of some humorous strips can reach into strange areas of idiosyncratic humor as George Herriman did with 'Krazy Kat'. Others, notably Walt Kelly with 'Pogo', introduced a strong, satirical layer of allegory, a running commentary on the passing show. If you latched on to that you got a bonus; if you did not then the strip with its comical verbal gymnastics was entertaining enough. Gary Trudeau's 'Doonesbury' is a later satirical/political strip with an enthusiastic following in many countries.

Cartoon shorthand

Naturally, through the course of time, a set of pictorial techniques and conventions evolved within the structure of the strip cartoon. Anger, amusement, and horror can be indicated by facial expression, but what about surprise? Surprise is shown by drawing the hat leaping off the head. A man is asleep, so a row of *Z*s issues from his mouth; but someone went one step further by substituting a saw half-way through a log in place of those *Z*s: the sound of snoring. A small cloud with a shining light-bulb in it placed above someone's head, indicates that he has just had an IDEA!

These are just a few of the recognized short-hand techniques. Then we are all familiar with the sound and action effects, the POWs, the WHAMs, the AAAAGHs—in their bursting, jagged balloons. As for the naturalistic action strips, the artist here needs to be a highly competent draftsman, able to draw anything and everything from any point of view. The construction of these naturalistic strips follows that of the movie director, varying close-up with long-shot, high angle and low angle. 'Modesty Blaise' in the London paper, *The Standard*, is a good example of the genre.

You could say that all cartoon strips follow a structure and form that has evolved into an accepted grammar; for all that, there is extraordinary variety within the cartoon strip conventions. Things are still evolving – we look forward to tomorrow's innovations.

Examples from two famous American strips: *Krazy Kat* by George Herriman and *Pogo* by Walt Kelly. **Above:** *Krazy Kat* ran for 28 years until its creator's death in 1944 and during that time it attracted the most fanatical following a comic strip has ever had. Strange, surreal, quirky – it was all of these and much more. The simply drawn characters acted against backgrounds which could change from day to night, say, between one frame and the next. **Top:** *Pogo* was more firmly and elaborately drawn, and employed a much larger cast of characters. Like *Krazy Kat* it often slipped into its own language and spelling. But unlike *Krazy Kat* it made its own droll comments on the current political scene.

Black humor

'Apart from that, Mrs Lincoln, how did you enjoy the play?' was an American 'sick' joke going the rounds a few years ago, something which showed that the murder of a revered president was an acceptable subject for a sophisticated and witty one-liner. It would not have always been so; public taste fluctuates, especially in the area of black or gallows humor, and there are extra variations of what is or is not acceptable from person to person, place to place, and period to period.

The phenomenon of black humor exists only because a lot of people like it; there seems to be a small part of our psyche which happily revels in that kind of thing (shades of our childhood attraction to the Grimm brothers' fairy tales). So death, physical deformities, religious beliefs and practices, respected national institutions – all these can be subject to the bad-taste treatment nowadays, provided they do not over-step the boundaries and provided they are witty enough. Cartoons nowadays about funerals and death generally, attempts at suicide, going to the electric chair, blind people and their guide dogs, appear so frequently that each of these themes must be regarded as a hoary cartoon cliché. Yet it is not that long ago when they would have all received the editorial

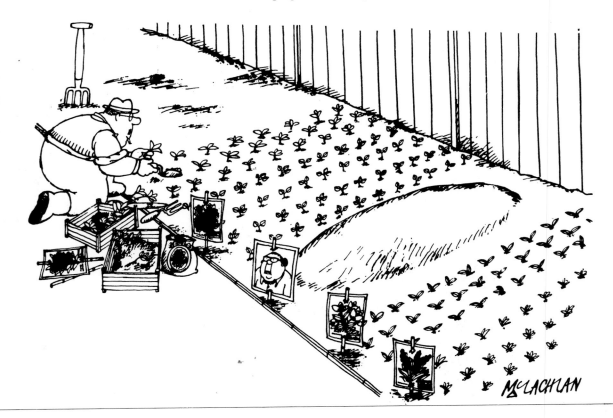

thumbs-down as taboo subjects. Magazines aren't eager to offend their readers.

Black humor seems to attract cartoonists of a similar style – or perhaps, more accurately, editors publish those of a particular style. These drawings are essentially 'cartoony' and intrinsically comical to dispell any notion of serious-ness. So a cartoon showing a man burying his wife in the back garden is acceptable to the public because the drawing itself is so comical and unrealistic. If it were drawn in a more naturalistic style, it would cease to be amusing. The cartoonist here is adopting the same ploy as the person who laughs loudly when telling a dubious joke.

So the cartoonist who branches out into the bad-taste section of the business and also seeks a wide and favorable response to his efforts must, to some extent, trim his sails to prevailing attitudes. If he over-steps the mark, especially with regard to gruesome decapitations and general nastiness, both editors and public will reject him. But he must, nevertheless, keep testing these frontiers of taste; there is plenty of evidence that many journals are happy to use certain kinds of cartoon today which would have been completely unacceptable to them only a few years back.

Of these three cartoons, the two making jokes about death are somehow more acceptable than the once concerned with minor mutilation, and the reason could lie in the contrasting styles of drawing. The Honeysett picture is not as stylized or 'comical' as the other two.

Also, the references to death are oblique instead of explicit. But there is nothing oblique about those severed fingers. The Birkett drawing is another example of 'delayed effect'. He invites the reader to search for, in this case, literally the point.

Cartoons with a message

Above: These two drawings were compiled as little decorations alongside paragraphs in an article dealing with accidents on swimming pools and the dangers of fires in hotels. The drawing style exploits the full range of a highly flexible pen nib.

Right: Larry, a very popular and long established British cartoonist, is employed here in this advertisement for British Telecom. The whole display is designed to look like a normal editorial cartoon, using the advertiser's slogan as the 'cartoon' caption.

A one-man band, playing alongside a theater line can be seen as a metaphor for the cartoonist. Each is a lone performer, each is relying on his own skills and devices with no assistance or collaboration from anyone else. The cartoonist regards his blank sheet of paper and knows that what will eventually appear there will come only from his own cogitation and ability to put the right marks in the right place. This can be daunting on occasions but at least he is in total control of the operation – the conception and its execution – and this can be a distinctly satisfying state of affairs.

But, because the cartoon, both humorous and political, has established itself as a potent carrier of ideas, it is not surprising that it has come to be seen as a very effective method of putting over ideas. Where of course this kind of activity predominates is in the field of advertising. And what most advertisers are after is the cartoonist's name and his familiar individual style. The public will stop and look at a cartoon advertisement because it expects to be amused. It is; but, surreptitiously, at the same time, it is also fed the advertiser's message.

Humorous drawing also assists officialdom to pass information to the population at large. In wartime or times of crisis this use can extend to include exhortation, advice, and the boosting of morale. And then there is illustration, where a cartoonist's talents are recruited to illuminate a book or an article or a magazine feature. These are often articles where the subject matter is heavy and unpalatable – the humorous drawing acts as a sweetener to persuade the reluctant reader to persevere. This 'collaborationist' side to the cartoonists' trade can be a very lucrative source of income.

Left: This is a drawing with a message indeed. Ralph Steadman aligns himself firmly with the animal conservationists in this incisive attack on the killing of seals for the garment trade. His fashion model splashed with blood is a very striking image.

Below left: Fougasse was a distinctive cartoonist who had the uncanny knack of catching subtle expressions and characteristic body movement, a skill he employed to great effect in his well known strip sequences. The design here is one of a series of 'careless talk' posters he did in colour for the Ministry of Information in World War II. Even within the sparseness of his style he demonstrates that he can effectively caricature Hitler and Goering. **Below:** This strip is a parody of the excessive chauvinism depicted in comic strips about the war, and is used here to encourage people to visit the Imperial War Museum in London for a more balanced view.

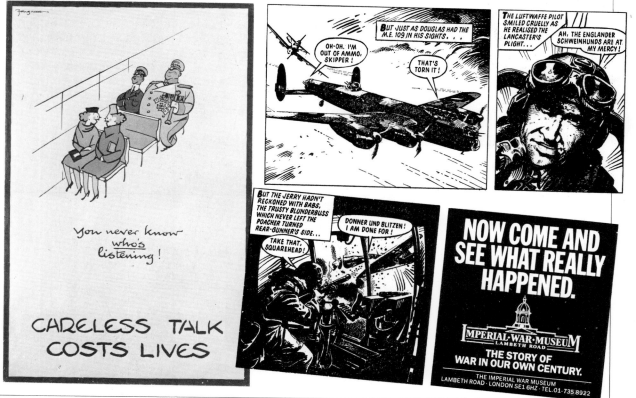

Computer graphics

I t would seem that computer technology is infiltrating just about every kind of activity you care to mention – and this does not exclude cartoon drawing. We are still a long way, however, from cartoons totally inspired by computer but there is hard and soft ware which can greatly ease the drudgery of cartoon drawing, speeding up the process involved in producing a finished piece of work. A cartoon sketch by an artist is quickly digitized onto the screen, and from this can be manipulated, duplicated and printed out.

A problem at the moment is in manipulating the 'mouse' terminal. Your drawing appears on a screen in front of you, not where you are 'drawing'. But this difficulty can be overcome with practice. There are systems now available using a 'light' pencil with which you 'draw' directly onto the screen. The technical bonuses are exciting. The artist can select the character of his line switching from 'brush', to 'pen', to 'pencil' or 'aerosol spray' in a second. The texture of 'fill-ins' and background can be chosen too. The system can be of particular help to the cartoonist who produces 'patched' work, cobbling together parts of several attempts to produce the final solution. On a computer, he can take an eye 'out', redraw the face and then replace the eye. Another useful effect is that mirror images can be obtained – draw one side of a vase and the other side is duplicated, even to kaleidoscopic images. Finally, when you are satisfied with your cartoon, a paper print-out, suitable for reproduction, can be obtained.

Can all this help the cartoonist? Well, it would very much depend on your style and the pressure of your work. Developments, like the light-pencil, are more use-ful to a wider group of cartoonists. Computer-drawn cartoons are a style in themselves and a cartoonist might turn to computer graphics when a futuristic or mechanical look is required. But they cannot achieve the character of line and infinite subtleties of the hand-drawn cartoon.

Wire-framed drawings, like this arm, are the best-known effect given by modern computer graphics. When the arm is moved or the point of view shifted, the computer works out exactly how the arm should look in its new position. But the computer does not have to display both the front and back views. It can fill in all the details of the detail of the drink and cope with movement and shift in point of view, maintaining perspective, shadow and the 3D effect at the same time.

One – or even two – pictures can be inset inside a third. Pictures can be squeezed, or stretched in any direction. They can be flipped, spun, mirrored, rotated. Colors can be changed at the touch of a button. Backgrounds can be switched – retaining the foreground shadow. In fact, with computer graphics, you can do any of the effects you see on TV sports and music programs.

Complex computer graphics effects are very expensive. The machinery used does not come cheap, nor do the trained operators. But less sophisticated graphics programs can be bought which run on home computers. They are usually driven by a palette, like this one, where you can decide whether you want to use a pencil, a paint brush, an airbrush or an eraser, what color you want to use – and you have a choice of pre-drawn features.

135

Cartoons as fine art

From what has been written so far, it is clear that the art of cartooning does not conform to a simple formula working within strict rules; it is, in fact, multi-faceted and wide-ranging and its boundaries are vague and ill-defined. But how close does it come to fine art? Here the boundaries *are* vague, with exponents of each craft occasionally crossing over into each other's territory.

A good cartoonist does not need to be a great artist. Certain cartoonists, however, work in a style which – almost incidentally – has strong aesthetic appeal. In Britain, Michael ffolkes and Quentin Blake come to mind; their work is lyrical and 'artistic'. Not surprisingly, Quentin Blake cites Picasso and Paul Klee (1879-1940) as strong influences on his style. In the United States, Saul Steinberg is an obvious candidate for a fine art award. His intellectual, fine-line drawings again echo the work of Klee.

Sometimes exponents of fine art display the talents of a cartoonist. Picasso, both in the economy and purity of line of his drawings and in the wit of some of his work, particularly the ceramics – qualifies as an honorary cartoonist. René Magritte (1898-1967), and other surrealists, displayed a love of pictorial illusion and visual puns – areas that cartoonists have adapted to their own use. And then, more recently, David Hockney, especially in his early paintings of the 1960s, has displayed a more forthright sense of humor – an elephant is shown in one painting walking on ground covered with the words 'crawling insects'.

Although Henri Gaudier-Brzeska was better known as a sculptor, his taut pen line and feel for flowing movement would be the envy of many cartoonists.

Left: Sixties pop artist Richard Hamilton used cartoon to parody two fine artists of an earlier era. The composition is taken from Velázquez with images – including the maestro's head – taken from Picasso.
Below left: LS Lowry uses a technique verging on caricature in this self-portrait.
Below: David Hockney's portrait of CP Cavafy in Alexandria uses the sparse appearance of the cartoon. But it is not funny, unlike some of his earlier work.

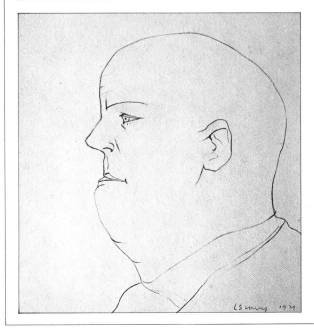

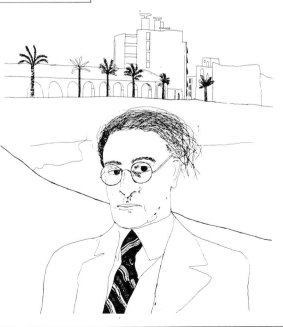

Glossary

Acetate A plastic material available in sheets. It is usually transparent or translucent, and is available colored or clear. It may have a mat or a shiny finish and is used as a support for artwork or as an an overlay.

Acrylic A polymer based in synthetic resin. In acrylic paints the pigment is bound with a polymer. Most acrylic paints are water soluble.

Airbrush A mechanical painting tool used to produce a fine spray of paint or ink.

Alcohol based These inks are used in many felt and fiber tip pens. They are not water soluble and are difficult to erase. Process white is ineffective but grey gouache can be used to touch up a line. They are valued for the speed with which they dry.

Balloons Areas within a picture which are separated from the rest of the image by a line and which contain text, usually speech.

Bleed A term used to describe the effect achieved when one color runs into another. In printing it is also used to describe that part of an image which extends beyond the trim marks on a page. Illustrations that extend beyond these margins are described as 'bled off'.

Blocking out To mask or paint out sections of artwork before reproduction.

Body color *See* **Gouache.**

Calligraphy Handwriting.

Caricature A drawing or painting of a person or thing which is deliberately distorted in order to create a comic or satirical effect.

Cartridge paper A general purpose paper with a slightly textured, hard surface. Very useful for drawing.

Cel Cellulose acetate, a plastic sheet material usually transparent or translucent which is available clear, colored and with a mat or glossy surface. It is used as the basis of artwork and overlays.

Characterization The ability to capture the essential qualities of an individual or a type.

Charcoal A drawing material made from charred wood. It is available as rather fragile sticks or in a harder pressed form. Charcoal is also available in pencil form. It is a powdery substance and a finished charcoal drawing needs to be treated with a fixative.

Chinese white A special brand of zinc white used in watercolor. Gives pure cool cover.

Clutch pencil This consists of a metal or plastic holder inside which is a sleeve which holds and protects the lead. The lead is secured in position by a clutch lock which is released by pressing a button at the top of the holder. This allows the lead to project further. Leads are available in a wide range of softness and widths, the smallest of which is 0.2mm.

Complementary colors Pairs of colors which are opposite each other on the color wheel. The three sets of complementaries are orange and blue, yellow and violet, and red and green.

Composition Refers to the way in which forms and color are arranged within a picture area.

Compositional lines These are devices to ensure that the viewer's eye is led to the central action of the cartoon.

Constant A device which is repeated in order to create a sense of continuity in a cartoon strip.

Draftsman's desk A purpose-built desk with an adjustable drawing surface and a parallel rule, a device which allows the artist to draw accurate parallel horizontal lines.

Dry brush A technique which, as the term implies, exploits a relatively dry brush and very little dilutent. Used in most paint media.

Detail paper Also known as layout paper, this is a thin, translucent paper with a hard surface which is used for layouts.

Felt tip pen The drawing points of felt tip pens tend to be larger and softer than those of fiber tip pens. They are available in a great range of shapes and sizes. Those with wedge shaped tips are ideal for laying in large areas of flat color.

Ferrule The metal section of a brush. It holds the bristles and attaches them to the brush handle.

Fiber tip pen These have fine points made of a synthetic material They are available in a range of point sizes and colors. The ink may be water soluble in which case it can be blended with a brush. The more permanent inks tend to be alcohol based.

Fixative A clear varnish solution which is sprayed over artwork or drawings to form a protective coating without altering the surface qualities.

Flat color An area of color in which there are no modulations of tone.

Flat wash A flat wash is achieved by laying an area of flat color with one stroke of the brush, working backward and forward until the whole area is covered with color in which there are no modulations of tone.

Fluctuating line A fluid line which is created by subtle control of the brush or pen.

Fountain pen Reservoir pens which are filled through suction.

Gag cartoon One in which a humorous situation or action is described within a single frame.

Glaze A technique in which transparent or semi-transparent paint is used to modify the underlying color. It is usually applied to work in oil or acrylic.

Gloss A surface which is shiny and light-reflective.

Gouache An opaque form of watercolor also known as 'body' color.

Graduated wash A graduated or graded wash covers the paper with the same color of paint but the tone varies in intensity.

Graphite A form of carbon which is compressed with fine clay and used in the manufacture of lead pencils. Graphite in powder form is also used by some artists.

Gravure A printing process in which the ink is held on the plate in recessed cells.

Guillotine A machine with a blade, used for cutting a large number of sheets accurately.

Gum arabic A water-soluble gum which is made from the sap of the acacia tree. It is used as a binder in watercolor, gouache and pastel.

Hatching A technique in which areas of tone are created by drawing fine parallel strokes.

Hiatus A method of drawing attention to a main character or object by surrounding it with an empty space. This is sometimes created by erasing the lines around the subject, or by organizing the composition in such a way as to achieve this effect.

Highlight The brightest part of the subject.

Hot-pressed (HP) paper Paper with a smooth surface achieved by passing the paper through heated rollers at the end of the paper-making process. Generally considered most useful for pencil and pen and ink work.

Indian ink Black, waterproof drawing ink. It dries quickly to a glossy finish and is particularly suitable for reproduction.

Lapis lazuli A bright blue semi-precious stone and the pigment obtained from it.

Letterpress A printing process in which ink is transferred from a raised printing surface.

Light pen A sensitive photo-electric device used to create or modify images on a computer screen by moving the pen over the surface of the screen.

Lithography A printing process based on the mutual repulsion of oil and water.

Mapping pen A dip pen with a very fine nib, originally designed for map making.

Mat A surface which is dull and non-reflective.

Mechanical separation A method of preparing artwork for the printing process which involves the creation of a separate layer of artwork for each color to be printed. These are usually prepared on a series of transparent overlays.

Mechanical tints Tints consisting of dot or line patterns that can be laid down on artwork before or during processing for reproduction.

Monochrome An image made up of different tones of the same color. Often used to describe images in black and white.

Mouse A device for communicating with a computer. The operator moves the mouse in order to create or adjust images on the screen. It is less direct and flexible than the light pen.

Movement echoes Little lines used to indicate repeated movements of an object or individual. They could, for example, be used to show the wagging of a dog's tail.

Nom de plume A writer's or artist's pseudonym, a borrowed name, title or initials which he or she uses for publication.

Not Paper with a very slightly textured surface achieved by passing the paper through cold rollers at the end of the paper-making process.

Oil paint Paint which consists of pigment mixed with an oil medium such as linseed oil.

Overlay A transparent piece of paper or film used in the preparation of multicolor artwork. The term is also used to describe a translucent sheet used to cover an original piece of artwork and on which instructions may be written.

Palette A dish or tray on which an artist lays out paint for mixing or thinning. They may be made of wood, plastic, metal or ceramic. The term is also used to describe the range of colors a painter uses in a particular work.

Perspective Any graphic system which creates the impression of depth and three dimensions on a flat surface.

Pigment The coloring matter of paints and dyes. Pigment can be made from naturally occurring or synthetic substances.

Pipette A slender tube used for transferring liquids from one place to another. The liquid can be sucked up the tube and held there by placing a finger over the top. Some pipettes have rubber bulbs which can be pressed to provide the necessary suction.

Poster paint An opaque water-color paint which is cheaper than gouache but is less permanent and coarser.

Primary hues or colors Pure colors from which all others can be mixed.

Process separation A photo-mechanical method of separating the colors for each printing plate. The artist provides one-piece of artwork and a camera is used to filter out each color.

Process white An opaque white gouache used for correcting and masking artwork which is intended for reproduction.

Quarto A piece of paper folded in half twice, making quarters or eight pages.

Reservoir pen A pen which contains a supply of ink. They are more transportable than dip pens which necessitate a separate ink container.

Rough Paper which has a distinctly textured surface, much favored by watercolorists though it is also suitable for certain drawing purposes and for mixed media work. An artist's rough is a sketch of the proposed image.

Rubber adhesive A commercially available adhesive favored by designers and graphic artists because it dries slowly and allows elements to be lifted and moved.

Saral This is a transparent paper which is used to transfer an image from one surface to another. It is available in five colors and in many ways resembles carbon paper.

Scalpel A small light knife with interchangeable blades, designed to be held like a pen.

Scumbling A technique in which the underpainting is overlaid by opaque, broken color so that it is partially obscured. Most usually applied to work in oil.

Secondary colors Colors achieved by mixing two primary colors.

Splattering A technique used to create texture or tone. A brush is loaded with ink or paint and the thumb is drawn across the stiff bristles. Alternatively, paint or ink can be flicked on to the picture surface.

Stippling Small dots used to create texture or tone.

Strip cartoon A series of small drawings or paintings which tell a comic or serial story.

Stylo tip pen A reservoir pen used by graphic designers. It is designed as a precision instrument and produces a line of constant width. Nibs are interchangeable and are available in up to 70 widths.

Thumbnail A small, quickly executed sketch in which the artist explores the possibilities of an idea. Particularly useful for sequential subjects such as strip cartoons.

Tone The measure of light and dark – often referred to as 'value'.

Variegated wash In a variegated wash different colors are allowed to bleed into each other. The effects that can be achieved are infinitely variable and cannot be repeated.

Wash The technique of applying paint, especially watercolor, by thinly diluting the paint and spreading the color quickly. Washes in pure watercolor are characterized by their translucency, whereas gouache washes are semi-transparent.

Water based Some felt and fiber tip pens contain water-based inks. These have some of the characteristics of watercolor, but it is not easy to combine the colors.

Watercolor Finely powdered pigment mixed with gum arabic, a water soluble resin. The paint is water soluble.

Whiz lines Broken lines used to indicate motion, speed and direction.

Index

Credits

Quarto would like to thank the following for permission to reproduce copyright material:
p 6 self-portrait caricatures by the authors; pp 8 (bottom), 10, 11 (bottom), 14 (top), 106 (bottom), 107, 110 (bottom), 111 (top and bottom right), 112, 113 (top left and bottom left), 114 (top, center and bottom), 115, 123 (top right), 131 (bottom right) *Punch*, London; p 9 Edward Koren; p 11 (top) Arnold Roth; pp 12 (left), 111 (bottom left), 130, 131, (bottom left) *Private Eye*, London; p 12 (right) Barry Fantoni; p 13 *Sunday Express*, London; p 14 (center) Osbert Lancaster; p 15 Jean-Jacques Sempé/ Dénoel, Paris; pp 66-7, 122 (top left), 132 (top left and center) William Hewison; p 108 (top) *Krokodil*, Moscow; p 109 Hans-Georg Rauch; p 113 (top right) André Francois/André Deutsch; p 113 (bottom right) James Thurber; p 116 John Leech; p 117 (top) *The Age*, Australia; p 117 (center) *The Observer*, London; p 118 (top) *The Times*, London; p 118 (center), 124 (center), 125 (top) *The London Standard*; p 119 John Jensen; p 120 (bottom right) by courtesy of the Trustees of the British Museum, London; p 121 (top left) *Sunday Times, London*; p 121 (top right), p 125 (center) *Daily Mail*, London; p 121 (bottom) Wally Fawkes; p 122 (top right) David Levine; p 123 (top left) E. W. Karlsson; p 123 (bottom) *Daily Mirror*, London; p 126 Editions Albert René/ Goscinny-Uderzo; p 127 (top) 'Bustards of the Bush', *The Australian*; p 127 (center) Posy Simmonds; p 127 (bottom) Claire Bretecher; p 128 DC Comics Inc, New York; p 129 (top) Hall Syndicate Inc, USA; p 129 (bottom) George Herriman; p 132 (bottom) British Telecom, London; p 133 (top) Ralph Steadman; p 133 (bottom left, center and bottom right) Imperial War Museum, London; p 134 (bottom) The London Software Studio; p 135 (top) Time Arts Inc, Santa Rosa, California; p 135 (bottom) Magnum Software, Chatsworth, California; p 137 (bottom left) Private Collection, London (photo, Walter Rawlings); p 137 (bottom right) by courtesy of the Redfern Gallery, London (photo, Walter Rawlings). All other cartoons have been drawn by Ross (Ross Thomson).

While every effort has been made to acknowledge all copyright holders, we apologize if any omissions have been made.

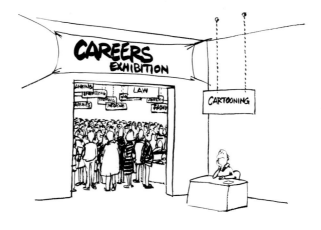